IMAGES
of AMERICA

SUMMIT
HISTORIC HOMES

D1194734

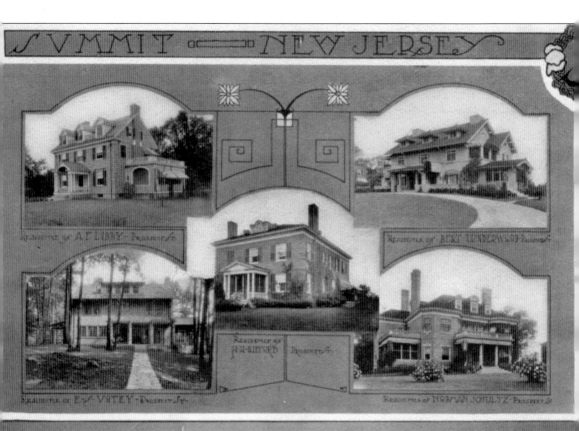

Summit, New Jersey – The Hill City – An Ideal Suburban Home Town, a brochure published in 1909, promotes the advantages of living in Summit. Its pages showcase various public buildings and the homes of prominent citizens and are filled with flowery descriptions of the town's healthy environment, convenient commute, and other desirable attributes. This page features residences on Prospect Street. (Courtesy of the Summit Historical Society.)

ON THE COVER: This house, purchased in 1859 by George Hartley LeHuray (1825–1893), a New York banker and early investor in Summit real estate, originally faced Springfield Avenue. It was moved to its current location, 9 Irving Place, around 1903, when LeHuray's vast estate, Mount Prospect, was subdivided. Here, posing in front of the house in 1894, are the George Meier family and coachman William Hickey. (Courtesy of the Summit Historical Society.)

IMAGES
of America

SUMMIT
HISTORIC HOMES

Cynthia B. Martin

ARCADIA
PUBLISHING

Published by Arcadia Publishing
Charleston, South Carolina

Printed in the United States of America

Library of Congress Control Number: 2013934647

For all general information, please contact Arcadia Publishing:
Telephone 843-853-2070
Fax 843-853-0044
E-mail sales@arcadiapublishing.com
For customer service and orders:
Toll-Free 1-888-313-2665

Visit us on the Internet at www.arcadiapublishing.com

To Bob, Jamie, Tim, and Lissa,
and life together in our historic Summit home

CONTENTS

Acknowledgments 6

Introduction 7

1. Early Days: 1830s–1850s 9

2. Township of Summit: 1860s–1870s 17

3. Country Seat: 1880s 35

4. City of Summit: 1890s 47

5. An Ideal Suburban Hometown: 1900–1910 67

6. War Years: 1910–1920 91

7. City of Beautiful Homes: 1920s–1940s 105

8. Two Summit Architects: Cady and White 115

Bibliography 126

About the Summit Historical Society 127

ACKNOWLEDGMENTS

This book would not have been possible without the support of my fellow trustees at the Summit Historical Society, and, for that, I thank them. With their permission, I spent countless hours in my temporary office at the Carter House going through the archives there, a true treasure trove of photographs, newspapers, books, maps, family histories, and other valuable resources.

In particular, I would like to thank Patty Meola for her proofreading, guidance, and moral support, Lynn Forsell for leading the way with her research, and all those who generously shared information and photographs with me. Last but not least, special gratitude goes to my family for their love and encouragement.

Unless otherwise noted, all images appear courtesy of the Summit Historical Society.

INTRODUCTION

Summit's development serves as an excellent example of the influence of the railroad on the built environment of northeastern New Jersey. As the region's expanding network of railroad lines made travel more convenient, the surrounding countryside became an increasingly desirable and accessible alternative to life in nearby cities. The advent of railroad transportation had an almost immediate impact on the area's landscape, which soon began to be transformed, as well-to-do city dwellers arrived and built both summer homes and permanent residences. In *Iron Rails in the Garden State*, Anthony Bianculli makes the following observation:

> Railroads, in general, were the facilitators of an ability to work at some distance from one's home. Nowhere was this fact more applicable than in northern New Jersey because of the great business and commercial magnet that was New York City. By 1840, only a few years after the first railroad had been established in the state, more than 700 workers were traveling to New York City from Newark and Jersey City via the New Jersey Railroad and Transportation Company's trains and ferryboats. Twenty years later, that number had swelled to over 4,300 commuters.

The railroad arrived in Summit in 1837 when the Morris & Essex Railroad began running cars from Newark to Madison with a stop at "the Summit," then a rural community of farms and approximately 250 inhabitants. The spot's bucolic charm and pure air coupled with the access afforded by the railroad drew wealthy summer visitors from nearby cities desirous of leading the healthy, country lifestyle promoted by popular publications of the times.

In the early days, travel by train was not for the fainthearted. The trip from Summit to Newark took about two hours. There were only two trains a day in each direction and, until 1899, no trains on Sundays. Continuing on to New York City involved additional effort and time. At Newark, horses towed the Morris & Essex railroad cars to the New Jersey Railroad line, where they resumed their trip and continued on to Jersey City. Upon reaching Jersey City, passengers disembarked and boarded ferries to cross the river to lower Manhattan, where they walked or took a carriage to their final destination.

As travel by railroad improved, an increasing number of visitors with professional ties to New York City, as well as Newark, Jersey City, and Hoboken, were drawn to Summit, filling its hotels for the summer season and building residences both as country homes and primary dwellings. Some considered Summit a prime real estate investment opportunity and proceeded to buy up and develop the area's farms. Today, many houses erected by these early residents still grace Summit's neighborhoods and many of the city's streets bear their names, including Larned Road, Colt Road, Whittredge Road, Kent Place Boulevard, DeForest Avenue, and DeBary Place.

In *Country Seats*, published in 1863, Henry Hudson Holly describes the advantages of country living:

> It seems scarcely necessary at this day to bring forward any formal arguments in favor of country life. It has been the favorite theme of philosophers and poets in all times. Its pure and elevating influences, its comfortable ease, its simplicity and cheapness, have been urged again and again in grave essays and pleasant pastoral and bucolic meditations.

While noting that some preferred spending only the summer months in their country homes, Holly also observes:

> There is another class, which, though compelled to spend the business hours of the day in the city, gladly hasten when these are over to peaceful homes, removed from the bustle and turmoil of the crowded town. This manner of living is becoming very popular, especially among the business community; and now that we have so many and ready means of communication between cities and their suburbs for many miles around, and at so trifling an expense, it is rather to be wondered at that more do not adopt it. The objection that too much time is thus lost in traveling to and fro is not well founded, since it actually requires but little more to reach a country place twenty miles from town than to go from an office in Wall Street to a residence in the upper part of the city.

Major improvements were made to the railroad lines connecting Summit with New York in 1854, 1868, 1905, and 1931. The ever-improving commute encouraged more and more newcomers to escape nearby cities and become full-time Summit residents. From the 1850s until the eve of World War II, Summit's population and building activity steadily increased, reflecting a national trend that John Stilgoe, in *Borderland: Origins of the American Suburb*, comments on:

> In the years between 1880 and 1930, hundreds of thousands of Americans moved to suburbs. According to a vast outpouring of magazine articles, the movement freed wives and children from all the unhealthful aspects of urban life, including the pace that killed spirit if not body. Of course, the men lived an even wilder existence, commuting back and forth on crowded trains leaving from ever more crowded terminals.

By 1940, Summit, no longer a seasonal destination, had been completely transformed from the sleepy, rural community of 1837 into a fully developed suburb with two railroad lines to New York and nearly 18,000 year-round residents, primarily commuters and their families. Today, many Summit residents still commute to New York.

Who were the city dwellers who moved here, what did they do, and why did they move here? This book tells their stories and showcases their homes while underscoring how railroad connections to nearby cities were integral in drawing them to Summit. The wealthy businessmen highlighted in these pages are certainly not the only ones who settled and built homes here, but their arrival and influence played a major role in Summit's development. It is the author's hope that this volume will give today's residents an appreciation for Summit's historic homes and their legacy.

One

EARLY DAYS

1830s–1850s

The railroad's arrival in 1837 did not immediately trigger development; for the following decade, Summit remained a rural community primarily composed of large farms. In the 1850s, real estate activity began to pick up, perhaps spurred by the more direct commute to New York afforded in 1854, when a bridge was built over the Passaic River connecting the Morris & Essex Railroad and the New Jersey Railroad lines.

One of the first city residents to seize the opportunity to escape to the area for the summer was James Kent, the chancellor of the Court of the Chancery of the State of New York from 1814 to 1823, who purchased a cottage in Summit in 1837. The railroad facilitated both Kent's access and that of his visitors, as evidenced by his friend Philip Hone's description of an August 1839 visit: "We came over the railroad through a pleasant and highly cultivated country in two hours, by Newark, Orange, and the Short Hills." Another early arrival was Rev. Thomas Cook, a priest of the Episcopal Diocese of New York, who built a summer home in Summit in about 1845.

Among those who arrived in the 1850s were prominent New York dentist Dr. Samuel Wheelock Parmly, who purchased land in the center of Summit in 1851; Nicholas D.C. Moller, a wealthy New York merchant who acquired Chancellor Kent's former property in 1854; Jayme Riera, Moller's business partner and son-in-law, who purchased 38 acres of farmland in today's Woodland Avenue neighborhood in 1858; Oliver J. Hayes, a wealthy Newark merchant who bought up 270 acres in eastern Summit in the late 1850s; George Hartley LeHuray, a successful New York banker who arrived in 1859 and accumulated a large estate along Springfield Avenue; and George Manley, a New York stockbroker and acquaintance of George LeHuray who purchased 28 acres near the intersection of Morris and Springfield Avenues in 1859.

In 1858, capitalizing on Summit's appeal and accessibility as a destination, its first hotel, Summit House, was built. Conveniently located near the train tracks, it attracted guests from the nearby cities of Newark and New York. Demand soon required the construction of an annex.

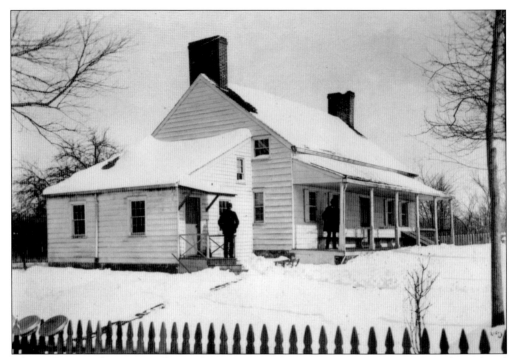

These photographs give an idea of the simple farmhouses found in Summit when the railroad arrived in 1837. Seen above in about 1903 is Carter House, which was relocated to 90 Butler Parkway in 1986 and now serves as the headquarters for the Summit Historical Society. Built in the 1740s, it originally stood on River Road. In 1837, it was part of the Ezekiel Sayre farm. The small, saltbox-style house at 73 River Road below also dates to the 1700s and was once part of the property connected to the Sayre family and Carter House. It is said to have served as housing for tenant farmers.

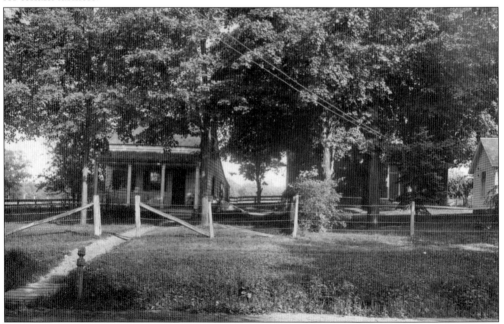

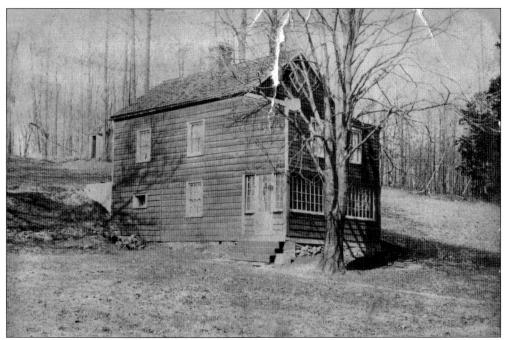

Two other early farmhouses are seen here. The home at 315 Ashland Road, pictured above, belonged to Josiah Doty, whose father, Joseph Doty, was one of Summit's earliest landowners. Built in the late 1700s, the original farmhouse has undergone many alterations over the years. Seen below is the residence of Jotham Potter, whose farm covered about 200 acres in what is now the center of Summit. In 1836, Crane Bonnel purchased Potter's farm and gave the Morris & Essex Railroad a right-of-way through part of it, thereby facilitating the construction of the railroad line through Summit. The house is no longer standing.

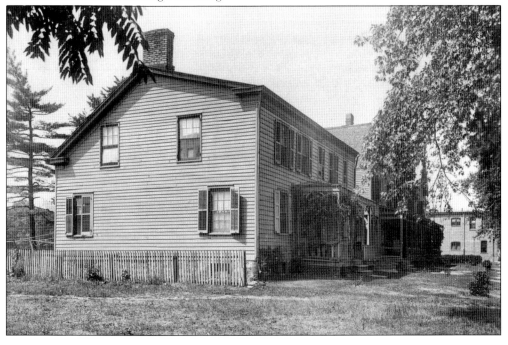

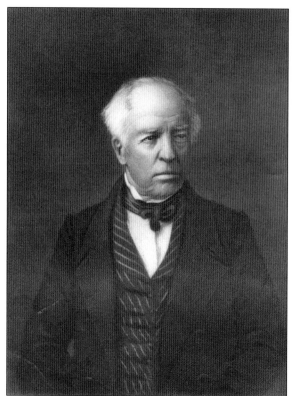

James Kent (1763–1847), the chancellor of the Court of Chancery of the State of New York from 1814 to 1823, was one of Summit's first summer residents. After spending several summers here, he purchased a cottage in 1837 on the present-day site of Kent Place School. Kent spent the last 10 summers of his life at his "charming country seat at my Summit Lodge."

Rev. Thomas Cook (1813–1884), a priest of the Episcopal Diocese of New York, arrived around 1845. His role in building Summit's first church, Calvary Episcopal (pictured), in 1854, was recognized at the time by the Right Reverend George Washington Doane, the bishop of New Jersey: "The Reverend Mr. Cook, officiating among the Germans in the City of New York, and full of work, having a country residence at Summit, conceived the generous plan of getting up a church there."

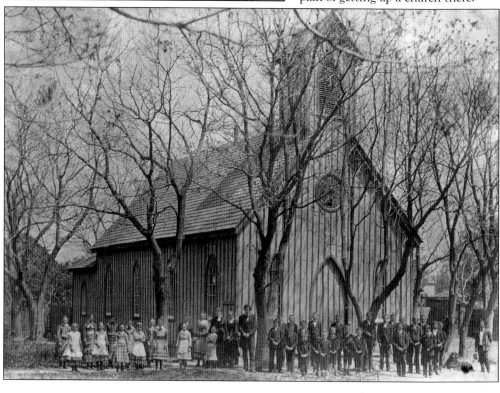

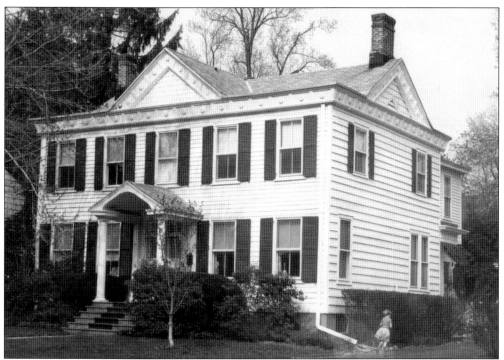

In about 1845, Reverend Cook built this house (above) as his country residence. Once located on Springfield Avenue where Wilson Park is today, it was moved to 21 Oakley Avenue in 1928. Around 1857, Cook built a girls' school across the street at 666 (now 668) Springfield Avenue (below). Nicknamed "Cook's Folly" because its concrete construction was not expected to last, it has served as a residence since the 1870s. Posing in front of the house are members of the Youngs family, who resided there from the 1870s to the 1920s. Cook owned property in Summit until at least 1872, but left in the mid-1860s after his first wife died.

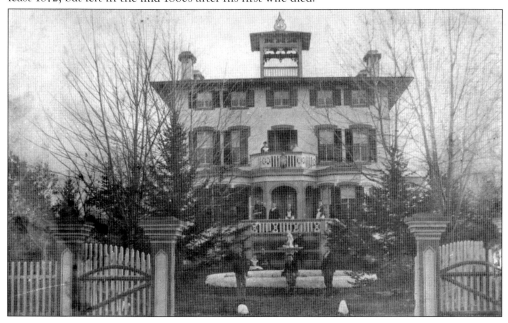

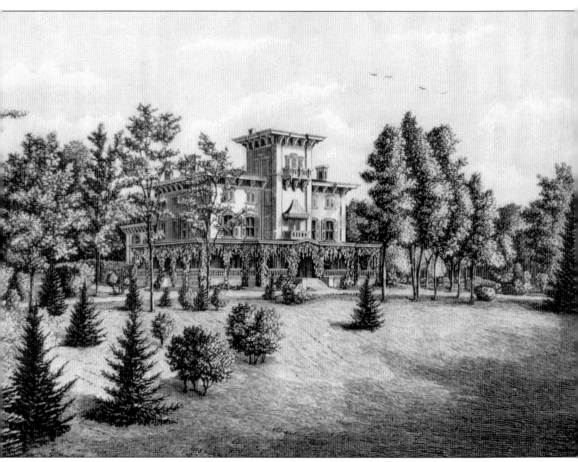

In the 1850s, a prominent New York dentist, Dr. Samuel Wheelock Parmly (1806–1880), purchased several properties in the center of Summit and built this Italianate mansion, seen here in an illustration from W. Woodford Clayton's 1882 *History of Union and Middlesex Counties*. Perched on top of the hill where Bouras Properties is located today, his estate extended down to Springfield Avenue. Parmly maintained his Manhattan practice and undoubtedly made use of the railroad. His obituary, published in the December 16, 1880, *New York Times*, observes, "Continuously since 1838, and up to the day immediately preceding his death, Dr. Parmly practiced dentistry in this City . . . He was a man of great success in his business, but of a very retiring disposition." In 1866, perhaps finding the commute too arduous, Dr. Parmly sold his estate to a New York lawyer, Jonathan Edgar (1825–1879), and moved back to New York.

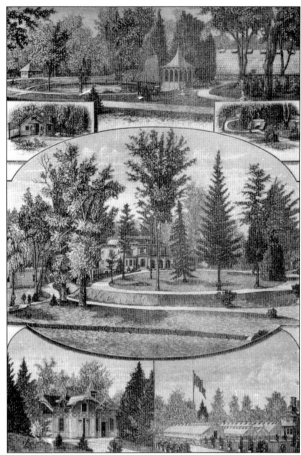

In 1854, Nicholas D.C. Moller (1800–1874), a successful New York merchant in the sugar and molasses trade, purchased Chancellor Kent's former property and built what another early resident, Reuben Manley, called "at that time the handsomest place in Summit." These two images give a good idea of what Moller's mansion looked like. The illustration at right, from Clayton's 1882 *History of Union and Middlesex Counties*, shows the property as it appeared when William H. DeForest owned it. The postcard below shows Moller's former home after it became Kent Place School for Girls in 1894. Today, the mansion is long gone but the school still occupies the site.

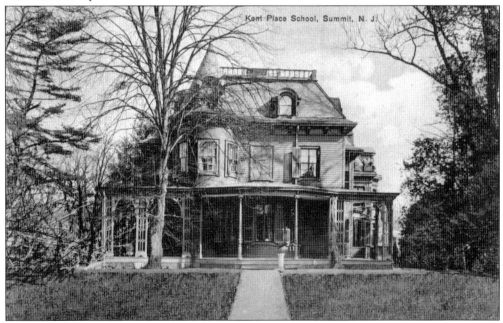

After acquiring Chancellor Kent's former estate, Nicholas D.C. Moller bought significant acreage from the Kent place west to the Passaic River, anticipating that the newly formed New Jersey West Line would need access through his properties. Amber Lodge, the house at 107 Passaic Avenue, was part of a farm he purchased around 1858. His daughter Isabella Morrison inherited it in 1875. Renamed Oakholm by a later owner, it has undergone multiple renovations.

George Hartley LeHuray (1825–1893), a successful New York banker and early investor in Summit real estate, purchased this house in 1859. His estate, Mount Prospect, eventually extended east along Springfield Avenue from about Irving Place to the railroad tracks. After his death, LeHuray's widow and children continued to live in Summit for many years. In about 1903, this house was moved from Springfield Avenue to 9 Irving Place.

Two

TOWNSHIP OF SUMMIT
1860s–1870s

Between 1850 and 1872, Summit's population grew from about 275 to about 1,300. More and more well-to-do businessmen from nearby cities were drawn to the area. They brought their families to spend the summer season, built summer and full-time residences, and invested in real estate, buying up and developing the area's farms. Some did well with their investments while others suffered financial ruin.

After Summit House burned down in 1867, two more hotels, Blackburn House, built in 1868, and Park House, built in 1871 with an annex added in 1873, were erected to capitalize on and accommodate the influx of summer visitors. In the 1870s, Summit began to experience an almost complete change of residents between May and October. Out-of-town guests filled the hotels and leased the homes of Summit residents who chose to depart for the mountains or the seashore. To help readers keep track of all this activity, local newspapers published weekly lists naming who was staying at which hotel, who was leasing their house and to whom, and who was vacationing at which resorts.

Improvements continued to be made to the railroads serving the region, undoubtedly enhancing Summit's appeal. In 1868, when the Morris & Essex Railroad was leased to the Delaware, Lackawanna & Western Railroad, passengers gained the ability to connect directly to New York from a ferry terminal in Hoboken. By 1870, construction had started on a new railroad, the New Jersey West Line, connecting Gladstone to Newark. Nicholas Moller hoped this project would require access through his properties but, although tracks were built from Gladstone to Summit, the line was never completed due to financial difficulties. Today, one can still make out the old New Jersey West right-of-way through backyards along Kent Place Boulevard and Bedford Road.

In 1869, the thriving community of Summit took the significant step of separating from the townships of Springfield and New Providence, under whose jurisdiction it had been governed. Several prominent residents, fed up with the lack of services and improvements Summit was receiving, successfully lobbied state government for legislation establishing Summit as a township in its own right.

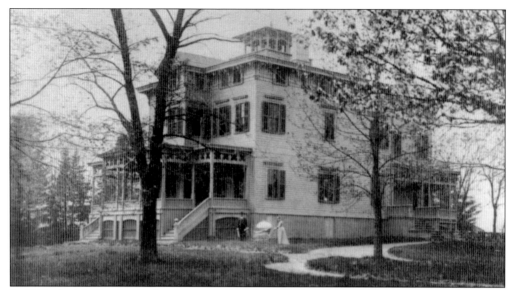

In 1860, the Manley family, former summer residents, moved into Elmsley, their new home on 28 acres near the intersection of Morris and Springfield Avenues where the Rosary Shrine stands today. George Manley (1818–1892), a prosperous stockbroker, regularly commuted to New York. In a 1924 *Summit Herald* article, his son Reuben relates how he too "became a commuter, going daily to school at the corner of Sixth Avenue and Fourteenth Street."

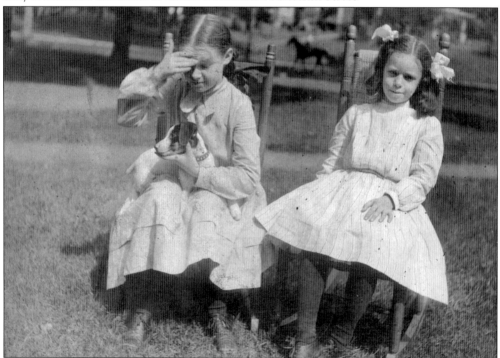

These two young ladies, seated on the lawn of Blackburn House in the summer of 1905, are identified on the back of this photograph as Marian C. Manley, her sister Virginia Dorothy Manley, and their dog Teddie. They are the daughters of George Manley's son Reuben and his wife, Harriet.

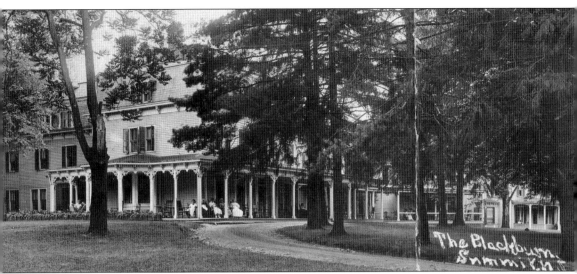

Having identified Summit as a prime investment opportunity, New York lawyer William Zebedee Larned (1821–1911) purchased 120 acres of the former Blackburn farm in about 1867. Larned's successful real estate dealings in both Summit and New York, combined with income from the law practice he maintained in New York until late in life, made him a wealthy man. An active Summit citizen, he served on the township committee, loaned funds to build the first school, served as the library association's first president, helped establish the first bank, and was a strong voice in the debate leading up to Summit's incorporation as a city in 1899. After acquiring the Blackburn farm, Larned began developing the property. In 1868, he built the Blackburn House, seen here. An early advertisement for this hotel proclaims that a "majority of substantial Summit residents are former Blackburn guests" and points out, "Summit is located on the Lackawanna R. R. . . . and is less than one hour from Herald Square." Today, the Grand Summit Hotel is located on this site.

P1058 The Park House, Summit, N. J.

In the late 1860s, Jayme Riera, Nicholas Moller's son-in-law and business partner, began developing Riera Park on the former Noe farm. This photograph shows the development's centerpiece, Park House, a hotel completed in 1871. Riera's venture was ultimately unsuccessful and, in 1884, his holdings were auctioned off. The announcement of his daughter Teresa's death in the July 29, 1899, *Summit Record* notes, "In the effort to maintain the Park House as the leading hotel of New Jersey and in his other investments, Mr. Riera squandered a fortune, and although his wealth was estimated at about three millions of dollars when he came to Summit, he left here practically penniless and was unable to retrieve his fortune before his death a few years ago." Continuing to operate as a hotel for many years, Park House was demolished in 1929 to make way for the apartments at the corner of Woodland Avenue and Hawthorne Place.

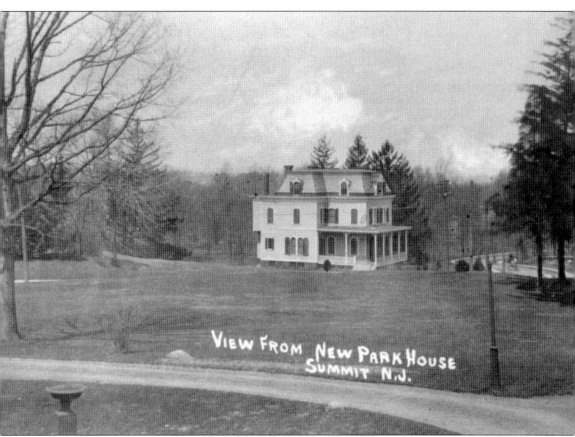

This bucolic scene shows what the Riera Park development looked like. In addition to Park House, seven houses were constructed as part of the 30-acre complex. Residents of these "cottages" were expected to take their meals at Park House. It became known as New Park House either after an annex was built in 1873 or when it was sold to William DeForest in 1884. A note on the back of this photograph identifies this house as the N. Whitehurst residence and states that it was built by Jayme Riera in 1871–1873. Samuel S. Whitehurst, an engineer with the Atlantic Terra Cotta Company of New York, lived at 58 Woodland Avenue with his family from 1911 to 1936. Perhaps his house, which is no longer standing, is the one seen here. The property on which it stood is now the site of Lincoln-Hubbard Elementary School.

Around 1869, William H. DeForest (1837–1896), a successful New York silk merchant, began investing in Summit real estate. He bought the Alton farm, near the intersection of DeForest Avenue and Kent Place Boulevard, and started developing Norwood Avenue, seen above in 1894, in partnership with John A. Hicks (1842–1911). In the early 1870s, DeForest built the houses at 32, 36, 40, 83, 85 (detail below), 88, and 95 Kent Place Boulevard, probably on speculation. He purchased the Moller estate in 1874 and then Riera Park in 1884. Also involved in major real estate transactions in New York, he overextended and went into bankruptcy. In the words of his friend William J. Curtis, DeForest, a "very delightful and agreeable personality," became "possessed" with purchasing real estate and did so to such an extent that he suffered "financial embarrassment."

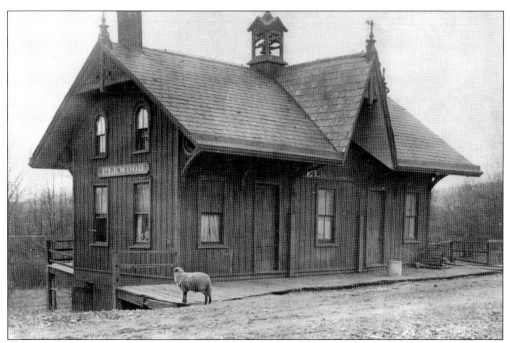

The Elkwood train station, shown above, was located near the intersection of Kent Place Boulevard, New Providence Avenue, and Mount Vernon Avenue. Appearing on an 1872 map of Summit, the station, originally called the New Providence station, may have been built as early as 1855. When the Delaware, Lackawanna & Western Railroad completed an ambitious program of upgrades in 1905, this station was abandoned. Not long afterward, it was moved to 73 Passaic Avenue and remodeled as a residence. Below, Mary Greene sweeps the sidewalk and gazes at 73 Passaic in 1911. Her grandfather Col. Richard Greene moved the former station to this spot and converted it for residential use. In the early 1940s, it was the home of Hamilton and Adelaide McGiffen, who founded their Elkwood Play School there.

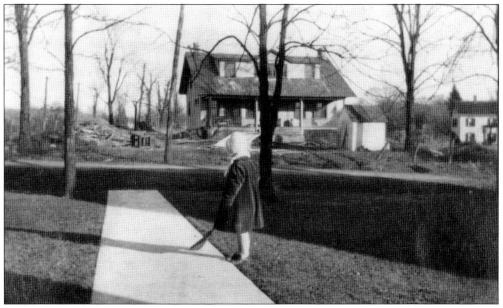

Both these houses are indicated on an 1872 map of Summit as part of George LeHuray's estate. His widow, Louisa, and their daughters Louisa and Emily lived in Rose House (above), at 14 Franklin Place, from about 1900 to 1916. Mrs. LeHuray's 1916 obituary notes that "the years of her widowhood were spent in one of the two pretty old-fashioned cottages on Franklin place, built by [LeHuray] in the days of his activity in Summit." While this house has been razed, its "twin," at 8 Franklin Place, still stands. Kettle Drum, at 49 Hobart Avenue (below), was the home of LeHuray's son Bowly (1867–1943) from about 1890 to 1923. It housed the Hood School in the 1920s and the American Red Cross from 1942 to 1945.

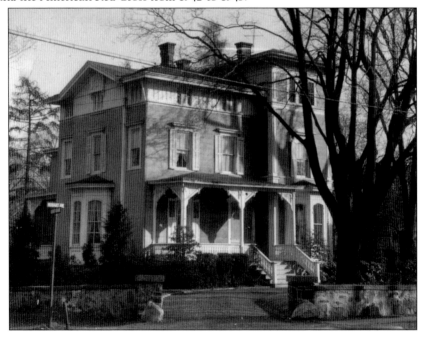

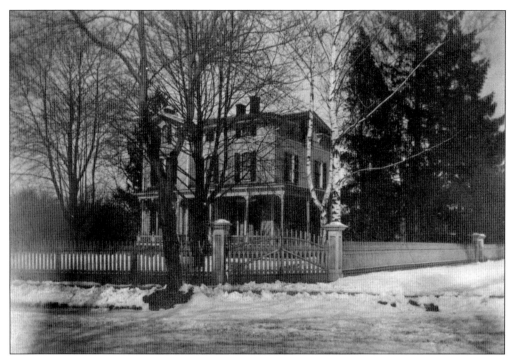

This house, at 663 Springfield Avenue (now 8 Fairview Avenue), was constructed in about 1870 for Lewis McKirgan (1837–1905), a Newark lawyer. Active in local politics, McKirgan served on the township committee and as a Union County freeholder. Seen here in the early 1900s, the house no longer has its original wraparound porch.

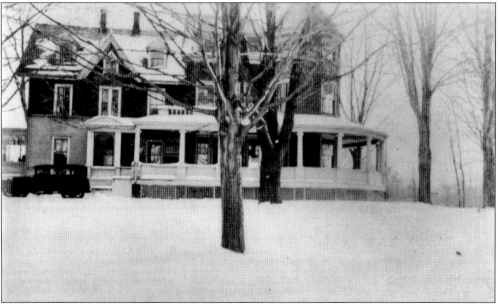

Cloverpatch was built around 1879 by George Jarvis Geer (1847–1924), a New York textile merchant. It was located at 212 Kent Place Boulevard, where Dunnder Drive is now. The Geers regularly leased Cloverpatch for the summer and during periods when they resided in Manhattan. Geer owned other properties in town and built several houses in the Crescent Avenue area.

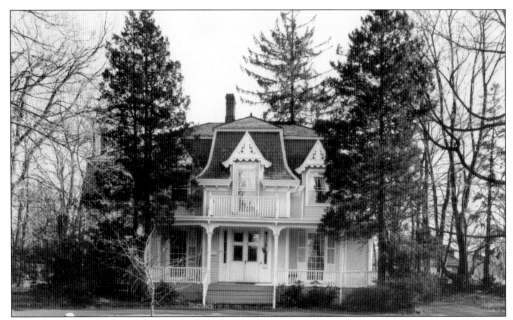

Melrose Cottage, at 196 Kent Place Boulevard, was built around 1875 by Frederick W. Moller (1835–1912) on property he inherited from his father, Nicholas D.C. Moller. The William J. Curtis family called the house The Nest, perhaps because four of their children were born while they lived there, from 1884 to 1897. In 1893, Curtis hosted a dinner in the house that resulted in the formation of Kent Place School.

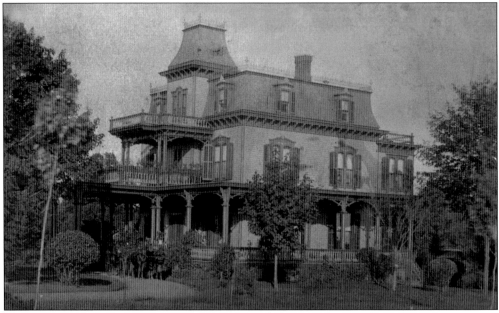

Frederick Moller's sister Clara Barr (1828–1900) inherited the property across the street, at 199 Kent Place Boulevard. Built around 1875, the house may have been used by the Barrs as a summer residence. Note the cupola crowning the central tower. After 1900, the cupola no longer appears in photographs of the house. The current owners have reconstructed it. (Courtesy of Kevin and Lisa Gardner.)

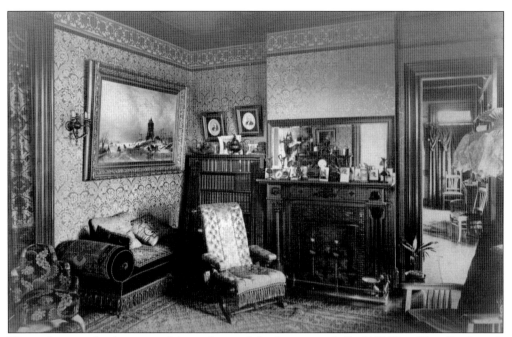

These photographs show one of the parlors and the front entry hall of 199 Kent Place Boulevard. Decorated in the eclectic style popular around 1900, they probably date from when Francis E. Dana (1836–1910), a Brooklyn lawyer, and his family resided here. The Danas owned the house from 1898 to 1910 and called it Linda Vista. The house appears in the 1925 supplement to the *Summit Herald* as The Conifers, the M.L. Heminway residence. In 1947, Hamilton and Adelaide McGiffin bought the house and moved their Elkwood Play School there. (Both, courtesy of Kevin and Lisa Gardner.)

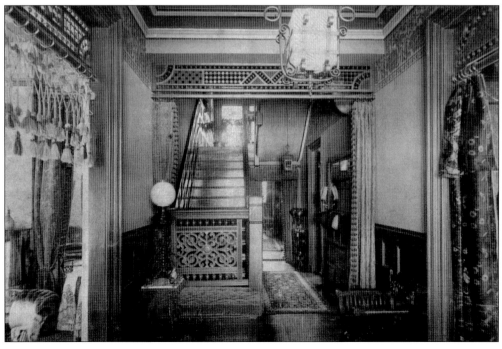

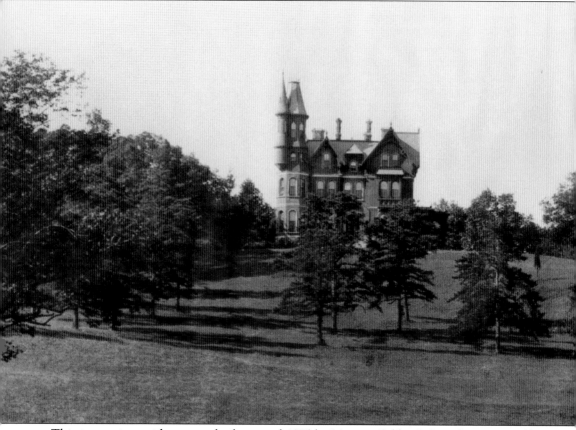

This impressive residence was built around 1875 by Morgan Gibbs Colt and was part of his 117-acre estate off Pine Grove Avenue. Colt's 1894 obituary notes that he was "one of the first wealthy men to perceive the numerous advantages possessed by Summit as a place of residence" and that his house was "one of the most beautiful and extensive homesteads in this section of New Jersey." Colt inherited his wealth from his father, Roswell Colt, a major stockholder in the Society for Establishing Useful Manufactures, which was founded in 1791 to promote industrial development along the Passaic River. Although he lived here only briefly and spent most of his life in Paterson, Colt retained possession of this estate until his death. The house was later used as a boy's school. In 1910, the property's sale was considered one of Summit's most important real estate transactions. The house was torn down in 1930; today, the Colt Road neighborhood occupies its former grounds.

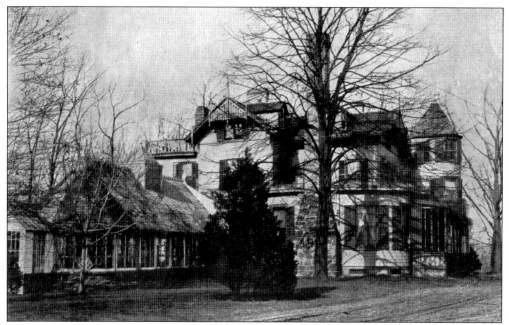

In about 1875, Gustav Amsinck (1837–1909), the head of Amsinck & Company, a major New York import-export firm, established a residence at 185 Springfield Avenue. He reputedly spent a fortune maintaining the house's grounds and gardens. In 1895, the *Summit Record* observed, "One of the most attractive features of a country home that is recognized as one of the most extensive and beautiful in this section of New Jersey, that of Mr. Gustav Amsinck, are the handsome, commodious conservatories with their magnificent assortment of the most rare and varied plants that have ever delighted the gaze of lovers of horticulture." Note the conservatory in the photograph above and the landscaping in the postcard below. Amsinck also maintained residences in New York, Germany (his birthplace), and Italy. His Summit estate was sold in 1916 and the house was subsequently demolished.

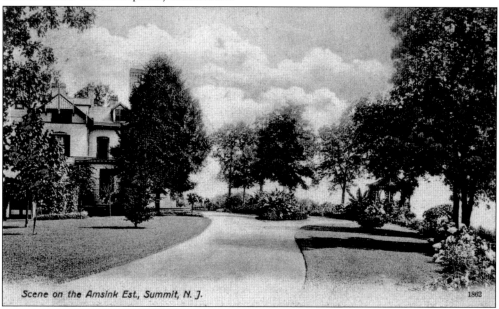

Scene on the Amsink Est., Summit, N. J. 1862

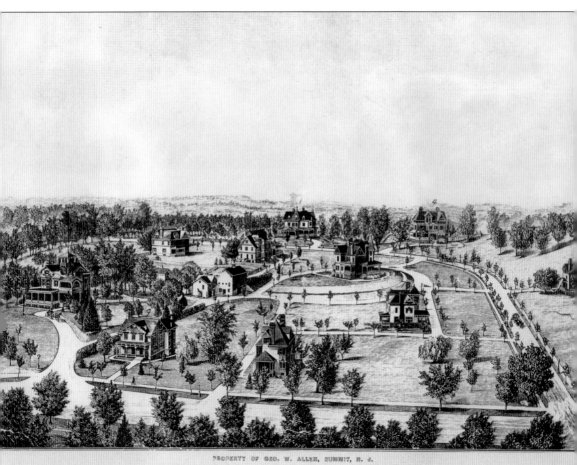

PROPERTY OF GEO. W. ALLEN, SUMMIT, N. J.
SHOWING NEW ENGLAND AVENUE AND IMPROVEMENTS, WITH HOUSES ERECTED
BY HIM AND BY PARTIES PURCHASING LOTS.

This illustration, from W. Woodford Clayton's 1882 *History of Union and Middlesex Counties*, shows New England Avenue, one of Summit's early premier residential neighborhoods. George William Allen (1845–1910), a successful New York wallpaper manufacturer, began developing the street in 1879. It ultimately boasted more than 20 residences. Many of these showcase homes were designed by New York architect Arthur B. Jennings (1849–1927) and exemplified the architectural styles popular at the time. In the 1940s, the grand old homes of New England Avenue began to be demolished to make room for modern apartment buildings. Today, not a single one survives.

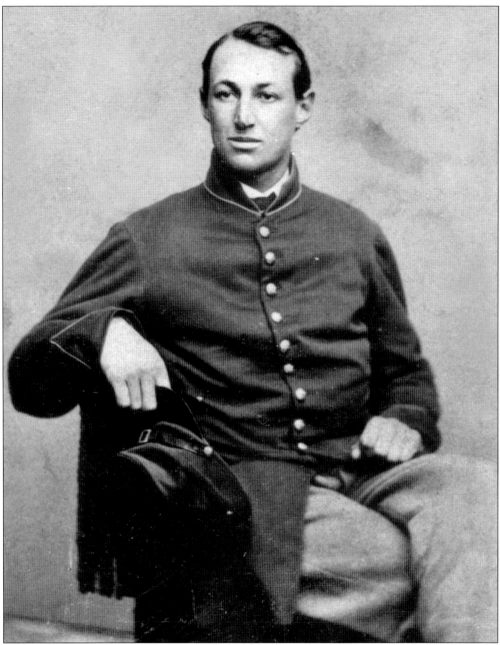

George William Allen was born in Meriden, Connecticut, in 1845. After serving in the Civil War with the 15th Connecticut Infantry Regiment, he entered the wallpaper manufacturing business in New York. Allen prospered and, in the early 1870s, came to Summit, where he invested in real estate and began planning New England Avenue. In 1880, Allen purchased Elmsley, the former home of the George Manley family, to use as his own residence. Around 1890, financial difficulties forced him to abandon the New England Avenue development and sell his real estate holdings. Allen's obituary in the February 26, 1910, *Summit Record* gives him credit as "another of those progressive men who early appreciated the beauties and advantages of Summit as a place of residence."

Pictured above is 79 New England Avenue, one of the first residences to be built on the new street. It was the home of Augustus Frost Libby (1841–1919), the head of a woolen goods firm in New York, and his family. The Libbys first came to Summit from Brooklyn in 1875, staying initially at Blackburn House before moving into a house on Kent Place Boulevard. Around 1880, they moved to 79 New England Avenue, where they lived until moving again in 1892 to a much grander residence on a new street, Beekman Terrace. The photograph below shows the house that stood at 100 New England Avenue.

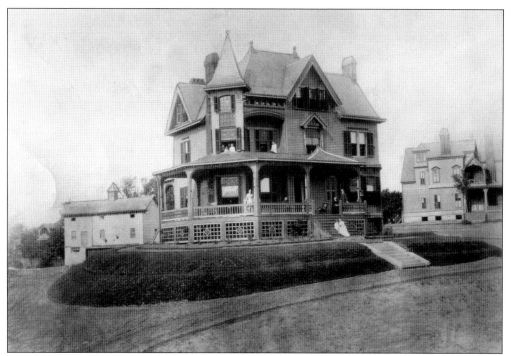

The house at 66 New England Avenue (above) was designed by Arthur B. Jennings, architect of many of the residences on the street. It was built in 1881 for George W. Allen's brother John Platt Allen. Like his brother, John was in the wallpaper business. Both brothers were associated with Fred Beck & Company, a New York wallpaper-manufacturing firm. The house at 67 New England Avenue (below) belonged to Henry E. Simmons (1833–1914), the secretary of the American Tract Society in New York.

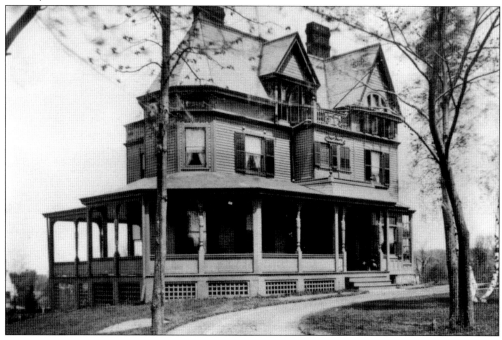

The home at 94 New England Avenue (above) belonged to John J. Merriam (1839–1910), a landscape artist with a studio in New York. The house at 91 New England Avenue (below) was the residence of John Northrup Peet, a New York businessman in the woolen trade and an officer of the Summit Trust Company. Other prominent Summit citizens with professional ties to New York who lived at one time on New England Avenue included Joseph H. Shafer, Anthony Comstock, John Kissock, and Walter D. Briggs.

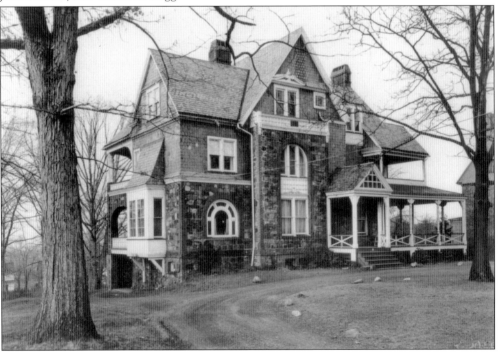

Three

COUNTRY SEAT
1880s

In 1880, Summit's population reached 1,910. A sense of how the town was developing is provided in W. Woodford Clayton's 1882 *History of Union and Middlesex Counties*:

> The town of Summit includes the whole of the centre and main road called Springfield Avenue, leading from the village of New Providence. The outskirts are surrounded with fine country-seats, the home of retired as well as business men from the adjacent cities of Newark and New York. Here can be seen fine villas, parks well laid out, and grounds with well-built mansions, while many extensive hotels and resorts for boarders are handy for the many trains which go from its depots upon the Delaware and Lackawanna Railroad, as well as the Passaic and Delaware Railroad depot at West Summit. It is a flourishing, picturesque town.

Although those who arrived sought relief from the trials of city living, existence in the country was quite an adventure. In 1889, tired of city apartment life, New York attorney Frank L. Crawford moved to Summit. In his autobiography, he recalls:

> Living conditions in that part of Summit were, at the time, rather primitive. At my house, there was no drinking water to be had, except when pumped from a well of uncertain cleanliness; no sewers, but only a cesspool; no water for general purposes, except from a cistern, from which it had to be pumped by hand to the third story; no light of any sort except from kerosene; and, of course, no telephone.

He goes on to explain:

> You may ask why I settled in such a place to live. It was partly because other towns were in much the same condition as Summit; partly because three of my old friends lived here; but chiefly because the Summit authorities promised explicitly that the lack of facilities should be remedied shortly, and so they largely were.

Like Crawford, many who moved to Summit during this time were motivated to do so not only because of its healthful climate and New York connections, but because their friends or relatives were here. New residents soon advocated for improvements to the town's infrastructure.

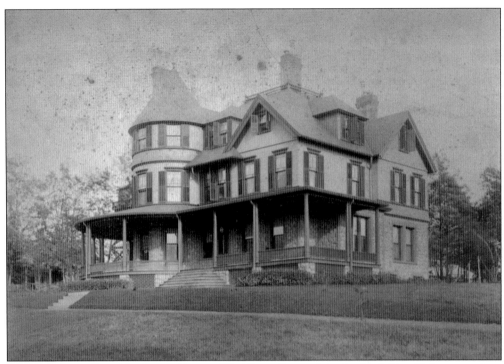

In 1880, after selling Elmsley to George W. Allen, George Manley built Fair Oaks, a gracious home on what is now the campus of Summit Oaks Hospital at 19 Prospect Street. The photograph below shows George and Mary Ann Manley sitting on the porch of Fair Oaks surrounded by their children, from left to right, Louis, Aliena, Reuben, Mary, Charlie, Caddie, and Herbert. Manley served on the township committee and, his obituary notes, "early foresaw the possibilities of the town's future and joined heartily in every movement having for its object the development of Summit's natural resources."

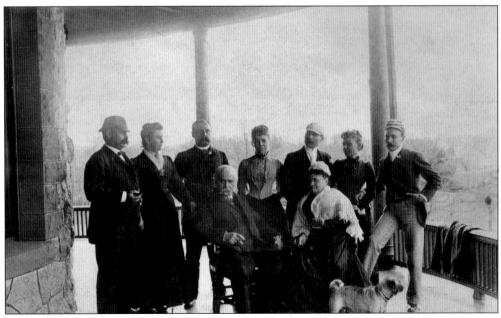

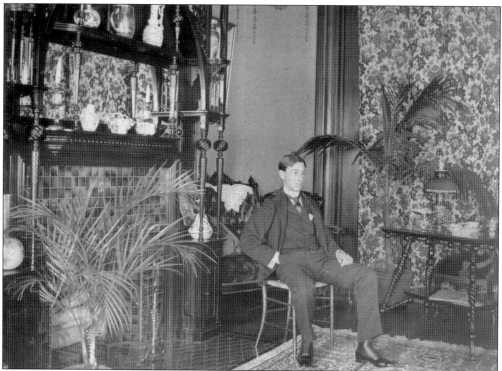

These two photographs provide a glimpse of the interior decor of Fair Oaks. A note on the back of the photograph above dates it to 1900 and identifies the man seated among the potted palms in the parlor as Jack. He is almost certainly Jack Manley Rosé (1883–1969), the son of Mary Manley and her husband, John Rosé, and a grandson of George and Mary Ann Manley. Rosé, an artist and a charter member of the Summit Playhouse Association, lived in Summit for most of his life. The undated photograph below shows the dining room of Fair Oaks.

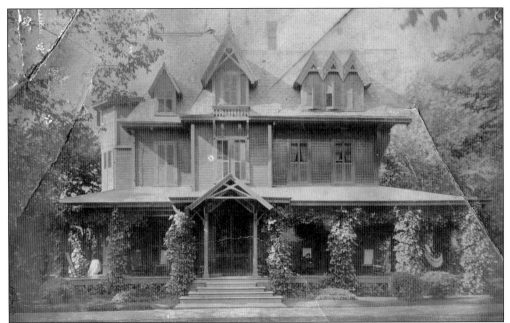

This house, at 265 Springfield Avenue, was built around 1880 as the country residence of Adolphe DeBary (1845–1928), a successful New York wine merchant. The DeBarys spent winters in New York and summers in this showplace home until they purchased another country residence in nearby Madison in 1906. This house's sale in 1916 was considered one of the most important real estate transactions in Summit at the time. Today, the building serves as the DeBary Inn.

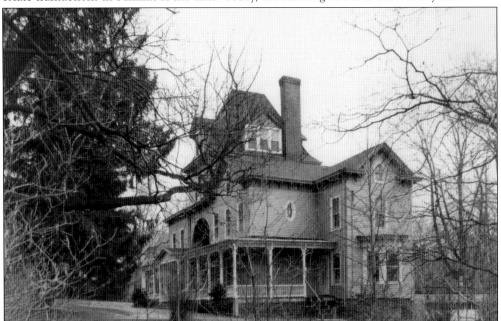

Holmdale, at 700 Springfield Avenue, was the home of Robert G. Hann (1841–1911), an actuary with the Equitable Life Assurance Society in New York. Hann purchased this house, then a small farmhouse, in 1882 and proceeded to enlarge it to accommodate his large family. Family members lived here until 1976, when a descendant of Pres. Rutherford B. Hayes bought the house.

Joel Garretson Van Cise (1844–1918) was an actuary with the Equitable Life Assurance Society in New York (like his neighbor Robert Hann) and an active Prohibition Party member. In 1886, he built the house below at 701 Springfield Avenue, described in A. Van Doren Honeyman's *History of Union County, New Jersey* as "one of the most beautiful residences of this district of fine homes. It is constructed of field stone taken from the grounds . . . Architecturally pleasing, within it reflects the cultivated tastes of its owners in arrangement and furnishing." The house was torn down in 1936. Van Cise also built one of downtown Summit's best-known buildings, 2 Kent Place Boulevard, which is now the home of Winberie's Restaurant. When constructed in 1893, it served as the local headquarters of the Woman's Christian Temperance Union and as a public meeting hall.

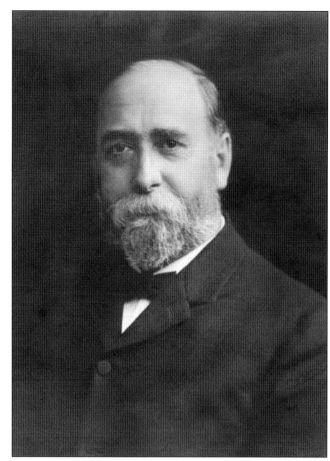

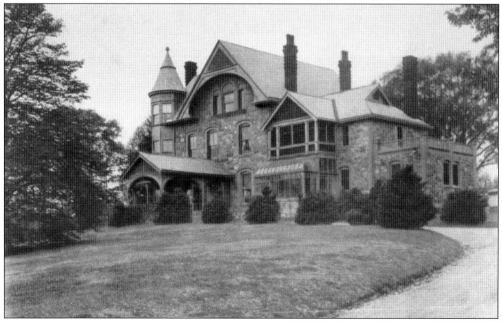

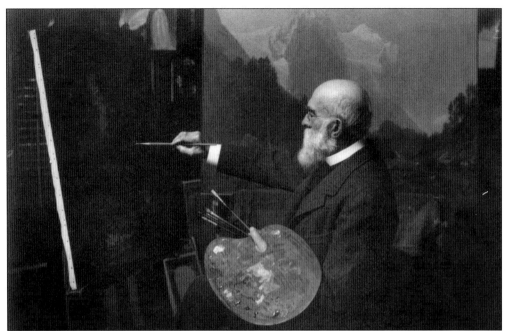

Hillcrest, at 166 Summit Avenue, was the home of Worthington Whittredge (1820–1910), a highly regarded landscape artist of the Hudson River School. A frequent visitor to the area, Whittredge identified this site as the most picturesque in Summit years before he purchased it. Built around 1880, the house was designed by noted architect and landscape designer Calvert Vaux. While he maintained a New York studio, Whittredge noted in his autobiography, "Summit was a region which had many attractions for me. There were wide stretches of forest land bordering on rich meadow lands along the Passaic, and from the hills, glimpses of the far-off Kill van Kull and of the great city could be obtained." In 1903, he moved to 18 Fernwood Road, where he lived until his death. His Summit Avenue residence was razed in 1928 to make way for apartment buildings.

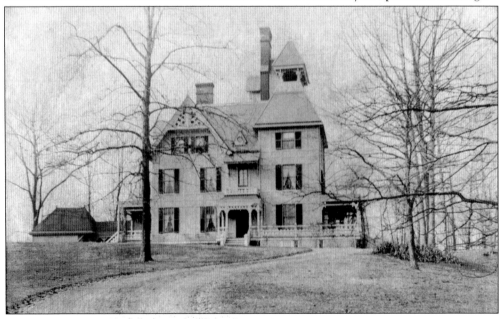

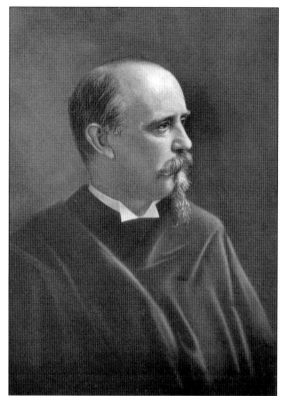

Stonewood, at 145 Summit Avenue, was built in 1884 for Alfred Wordsworth Thompson (1840–1896), a noted painter of genre and historical subjects who, like Whittredge, had a studio in New York. His career was launched when his sketches of Civil War scenes were published in *Harper's* magazine. In *History of Union County, New Jersey*, A. Van Doren Honeyman relates how, when Thompson "sought the place he might permanently call home, he found it in a delightful residence built under his direction in Summit, New Jersey." After Thompson's death, his widow continued to live in the house for many years. It was eventually replaced by apartment buildings.

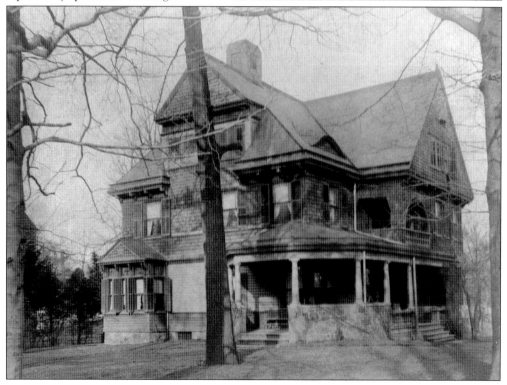

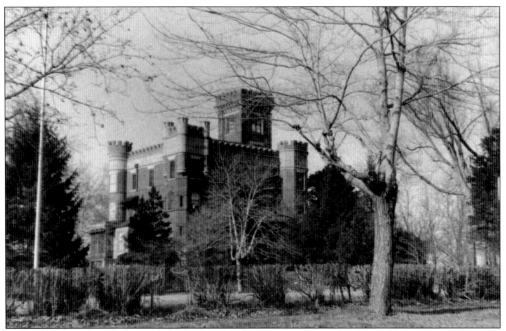

Built around 1885, this castle-like residence stood on River Road at the Chatham border until it was demolished in 1969 to make way for Route 24. It was the summer home of George B. Vanderpoel (1846–1925), a member of an old, politically connected New York family. Vanderpoel inherited the property, his family's homestead since the 1700s, in 1874. The first home he built on the site burned down in 1882.

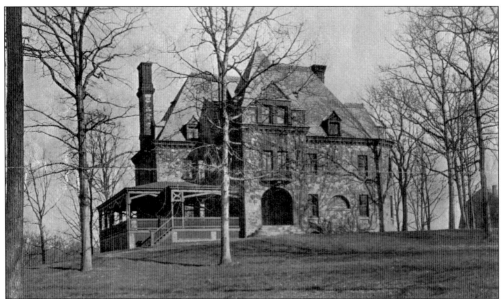

Continuing his development of the former Blackburn farm, William Zebedee Larned opened Blackburn Road around 1880. In 1887, he moved his family into this magnificent stone mansion, Stoneover, which is now part of Oak Knoll School. Larned's real estate dealings and law practice made him a wealthy man. He supported a variety of civic endeavors, served on the township committee, and lived in this house until his death.

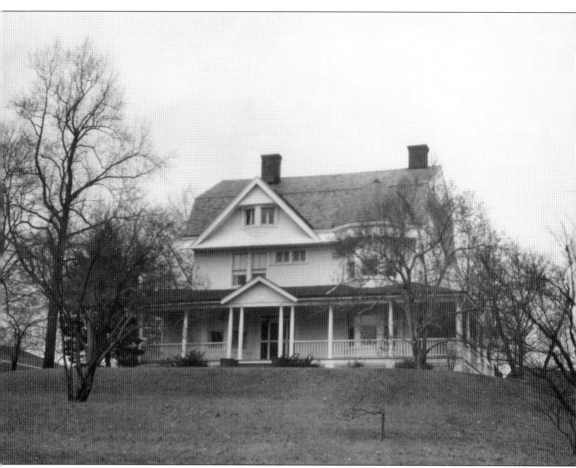

Moraine Crest, at 3 Whitesell Court, was built in 1889 for Hoboken lawyer William Cranstoun (1854–1920). Its original address was 619 Springfield Avenue. The August 31, 1901, *Summit Herald* reports, "Summit is noted for its many beautiful residences and handsome natural building sites. One of the most attractive places in Summit is that of Mr. William Cranstoun, 619 Springfield avenue. In addition to the natural beauty of the elevation, Mr. Cranstoun has the grounds artistically laid out with flowers and shrubbery and kept in perfect condition, and his vegetable garden is unsurpassed in the city. Mr. Cranstoun has recently made extensive improvements to his beautiful house, which was built about ten years ago." According to notes made by his son Kenneth, Cranstoun moved to Summit for his wife's health. After her untimely death, he remarried and built this house, where he lived until moving to Connecticut in about 1912.

In 1889–1890, John and Isabelle Wisner built this home on about 12 acres of the former Swain farm. The Clearing, at 165 Hobart Avenue, was the first house to be constructed in this part of town. It was designed by New York architects Babb, Cook & Willard. In 1889, the *Summit Record* reported that the Wisners' new home was "to be built facing the south with no verandas in front so that there can be no obstruction to the light and heat in winter." John Hornor Wisner (1845–1920) was associated with his family's import-export business. He and his wife spent several years in China, and three of their children were born there. Evidently, Mrs. Wisner feared for the children's health there, and they moved to New York in the 1880s. The Wisners came to Summit on the advice of friends and lived here until 1916, when they returned to Manhattan. They often leased their home for the summer. Today, the house and grounds serve as the Reeves-Reed Arboretum.

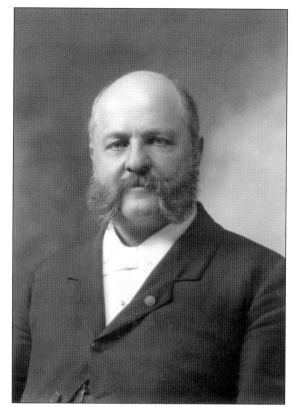

Anthony Comstock (1844–1915), the world-renowned reformer and founder of the New York Society for the Suppression of Vice, moved to Summit from Brooklyn in 1883 and built a home on New England Avenue. In 1892, he moved to Breezecrest (pictured), a new home he built at 35 Beekman Road. Comstock's houses were often listed in the local paper as leased for the summer. "His residence here," according to a 1940 *Summit Herald* article, "brought Summit to the attention of a greater number of newspaper readers than almost any other individual then here." Breezecrest was Comstock's home until his death. It was razed in 1999.

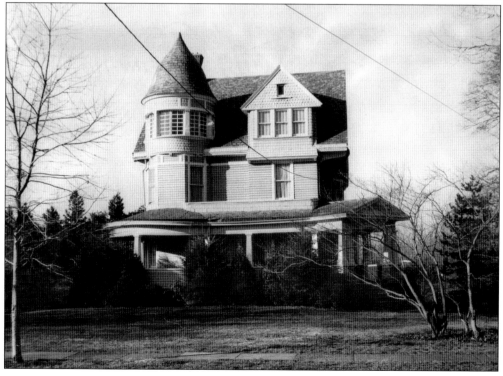

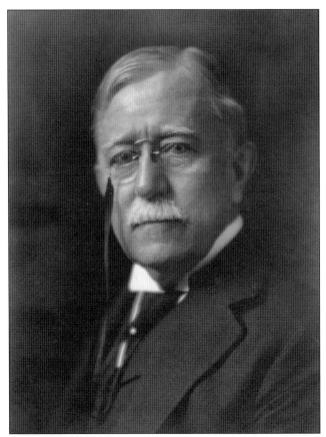

In 1888, hoping that the climate would improve his wife's health, renowned literary figure Hamilton Wright Mabie (1846–1916) moved to Summit. The Mabies built their first home on Morris Avenue and lived there until 1895, when they built the house pictured at 3 Fernwood Road. They often leased their home while spending summers elsewhere. A prolific author, Mabie also played a prominent role in Summit life. He was one of the founders of Kent Place School, serving as the commencement speaker for many years, and was instrumental in securing funds from Andrew Carnegie to build a new public library in 1911. He resided at 3 Fernwood until his death. (Below, courtesy of Everett H. Scott.)

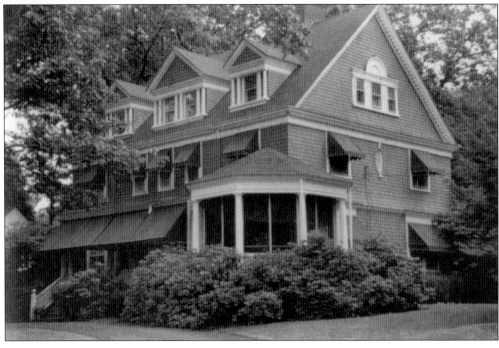

Four

CITY OF SUMMIT

1890s

By 1890, Summit had 3,502 residents and a commute to New York City of 76 minutes. The July 19, 1890, *Real Estate Record and Builders' Guide* observes:

> There are over 13 times as many commuters to places in New Jersey as to the north of New York city; or to put the matter in a more forcible light the number of commuters travelling within 20 miles of New York to the New York Central, the Harlem road and the New York and Northern is 1,747 whereas, to Elizabeth, N. J., alone on the Pennsylvania line the number is 3,300. The explanation of this fact is perfectly clear: New Jersey has ample first-class railroad accommodations and New York has not.

Local newspaper headlines, including "Unparalleled Development: How Summit Residents are Building and Improving" (*Summit Record*, November 26, 1892), and "Building Interests: Number of Houses Under Way and Many Being Considered" (*Summit Herald*, July 29, 1899), indicate the pace of development during this period. The papers continued to publish lists of the increasing number of summer visitors staying at hotels or leasing houses. To accommodate this seasonal influx, the Beechwood Hotel, with rooms for up to 250, was constructed in 1893 on the site of the former Parmly mansion.

In 1897, Frederick W. Ricord noted in his *History of Union County, New Jersey* that at least 25 residences had been built in Summit in the previous six months at a cost of about $150,000 and that the demand for property was strong. He enthusiastically observes:

> Summit has but to be seen to be admired. Many who have come to this overlook town for a brief summer stay have been so captivated by the charms of the village that they have located here permanently . . . They have been attracted to this place for the heated season not less by nature's ample provision of pure air and beautiful scenery than by the sumptuous equipments of its palatial hotels and many large boarding houses.

By 1898, Summit boasted 5,000 residents and a vastly improved infrastructure. In 1899, taking advantage of new legislation, Summit was incorporated as a city.

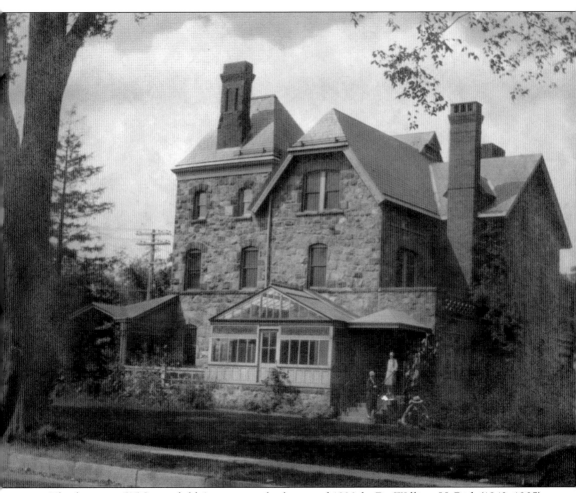

This home, at 535 Springfield Avenue, was built around 1890 for Dr. William H. Risk (1842–1905), one of Summit's first physicians. Dr. Risk moved to Summit in the early 1870s. In addition to practicing medicine, he acquired and developed a considerable amount of property in the northeastern part of town. Although not a New York businessman, he played a significant role in Summit's early development, as noted in his obituary, published in the *Summit Herald* on February 11, 1905: "He always took an active interest in all local affairs; coming to Summit when the town was in its infancy, he was largely instrumental in its rapid growth and development into a beautiful and influential little city." After Dr. Risk's death, his brother Dr. James Boyd Risk lived in this house. Seen here standing on its steps are James's wife, Mary, and their daughter Mary. Today, the house is barely recognizable as part of an office building.

Seen here around 1905, this sprawling mansion still stands at 14 Bedford Road. Called Avebury, it was designed by New York architect Wilbur S. Knowles and built in 1890 for James L. Truslow Jr., a regular commuter to New York, where he was associated with his family's cork business, Truslow & Company. When he passed away at age 51 in 1899, his obituary commented, "He was deeply interested in the property comprising this estate, and all of the time that he could spare from his New York business for the past three years was devoted to the development of plans for making it one of the handsomest estates in New Jersey. Most of this work has been completed." Now part of Oratory Preparatory School, the house is currently slated for demolition as part of a campus improvement project.

Both these houses were built in 1890 and designed by New York architects Stephenson & Green. The house at 113 Hobart Avenue, seen above in 1914, was the residence of Francis Southmyd Phraner (1858–1922), an executive with the New York firm of Baker & Williams, owners of warehouses. Active in civic affairs, Phraner served on common council and as a trustee of Kent Place School. After his death, his daughter Mary lived here until her death in 1978. Seen below is Ingleside, at 119 Hobart Avenue, the home of William Darrow Jr. (1860–1927), an executive with the New York Trust Company.

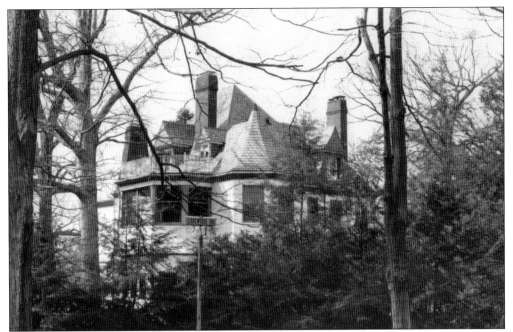

This home, at 21 Edgewood Road, was built in 1890–1891 for Parker Webster Page (1851–1937), a New York patent attorney. His brother Harvey L. Page was the architect. Built on property that was once part of the Amsinck estate, it is one of the homes featured in the 1894 *Souvenir of Summit*. It was recently demolished and replaced with a large new residence.

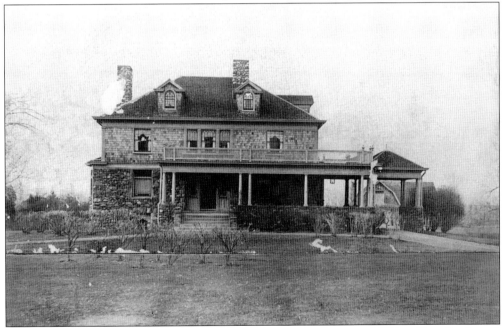

The September 1899 issue of *Ladies' Home Journal* features this home, at 149 Kent Place Boulevard, as one of "the prettiest country houses in America." It was built in 1891 for Albert Wellington Newell (1849–1910), the head of the New York office of Newell Manufacturing Company, which made buttons. The Newells lived here only briefly.

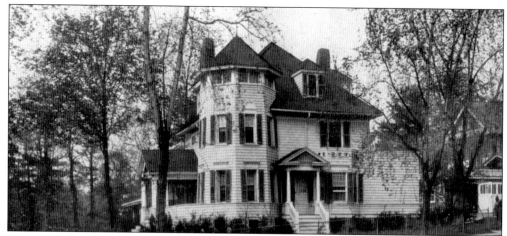

Designed by Louis R. Hazeltine, this home was built at 7 Norwood Avenue in 1891 for John Brewer, the head of New York stationery firm H.K. Brewer & Company. When it was under construction, the *Summit Record* reported, "The house will be original in design and artistic in outline. It will follow none of the conventional styles of architecture but will when erected prove an ornament to the section of town in which it is to be located."

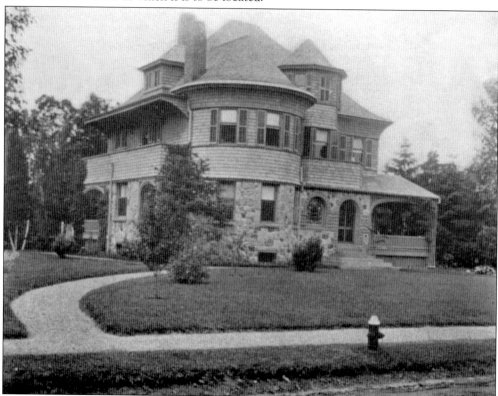

This home, at 32 Hobart Avenue, was built about 1895 for Charles F. Wood (1852–1927), a New York diamond merchant. While living in Summit, Wood served on the township committee, the first common council, the board of education, and the YMCA's board of directors. Councilman Wood and his residence are featured in the souvenir booklet for the 1900 Labor Day fire department parade. He relocated to New York in 1913.

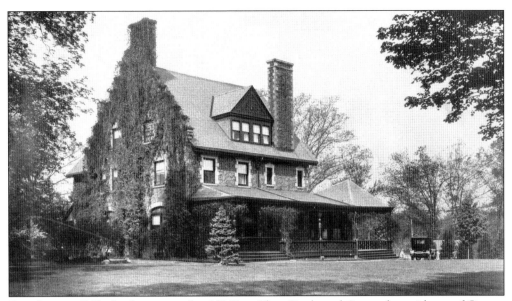

Seen here in 1925, this house stood at 160 Kent Place Boulevard. It was the residence of George Wellington Dillingham (1841–1895), a well-known publisher with G.W. Carlton & Company in New York. Dillingham lived here from about 1892 until his death. His widow continued living in the house until 1901.

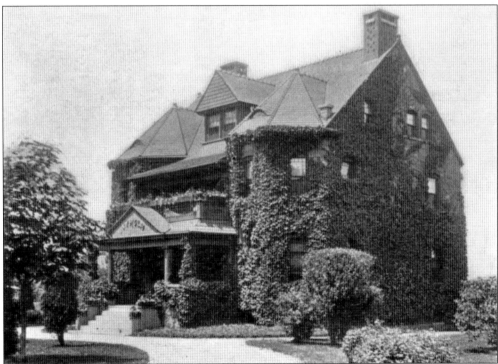

Ivyholm, at 115 Kent Place Boulevard, was the home of George Wilcox (1839–1907), a New York attorney and Summit's first mayor. Wilcox was persuaded to move to Summit by Francis E. Dana, who lived at 199 Kent Place Boulevard and was married to a sister of Wilcox's wife, Mary. The house was built around 1884 by William H. DeForest and purchased by Wilcox in 1894.

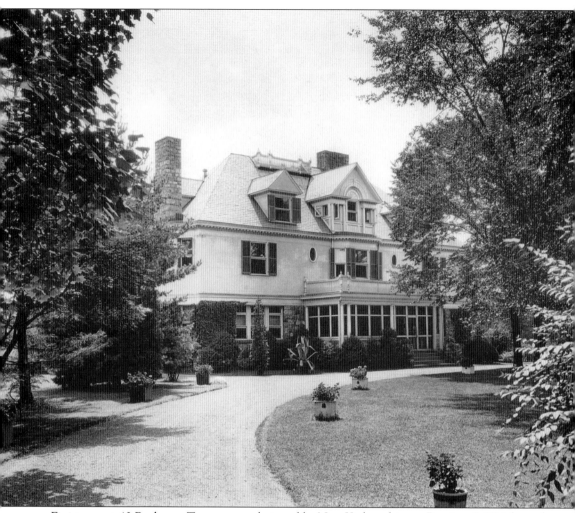

Finisterre, at 40 Beekman Terrace, was designed by New York architects Rossiter & Wright and built for Augustus Frost Libby (1841–1919), head of a New York woolen goods firm. The Libbys moved here in 1892 from 79 New England Avenue, their previous, more modest home. Still standing, this magnificent residence is among the homes featured in the 1894 *Souvenir of Summit*. The house is seen here in about 1907, after it was sold to Nicholas Benziger. On September 28, 1907, the *Summit Herald* printed this caption under a picture of the house: "Home of Nicholas Benziger, Beekman terrace, recently purchased from Augustus F. Libby, is one of the many show places about Summit: the building was erected by Mr. Libby in 1892, the first story is of Boonton conglomerate boulder, and the upper part of sheathed woodwork with heavy cornice of colonial order. The building contains eighteen rooms, and has two fronts, one on Beekman terrace and one on Springfield avenue. Its situation commands an extensive view on the Passaic valley and Long Hill, Boonton and the Watchung mountains."

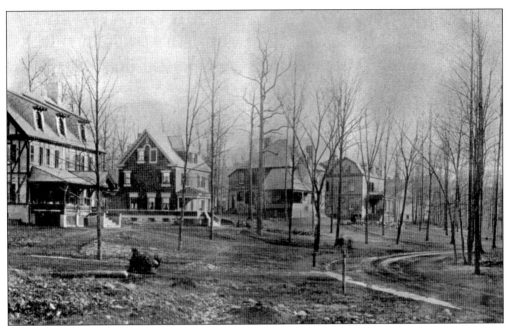

These photographs show two of the residential neighborhoods developed in the 1890s. The photograph above shows newly constructed homes on Hillcrest Avenue in 1894. In an 1891 brochure promoting Hill Crest, its author, well-known writer Gustav Kobbé, enthuses, "One breathes on Hill Crest a dry, bracing mountain air . . . The Hill Crest property has been improved with a view of creating a locality whose advantages would appeal to people of taste. The pioneer work of settlement has already been done, there being a number of occupied residences on the site." Crescent Avenue is seen in the photograph below. Homes first appeared on this street in the 1890s, and George J. Geer built several houses there in the early 1900s as investment properties.

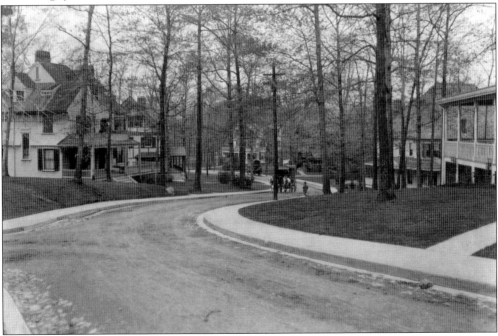

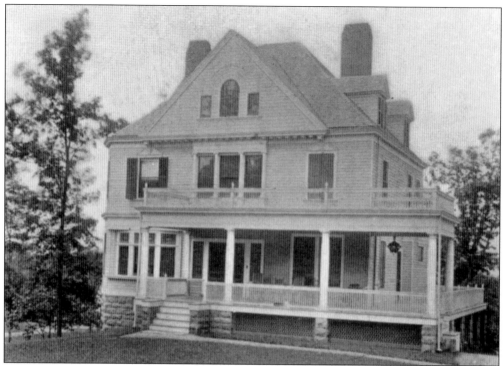

Glenoaks stood at 3 Beekman Road. Designed by W. Frank Bower, it was constructed in 1893–1894 for Charles A. Munger, a New York businessman. Munger lived here only briefly, as business required him to move to Boston in 1901. The house was leased until at least 1909.

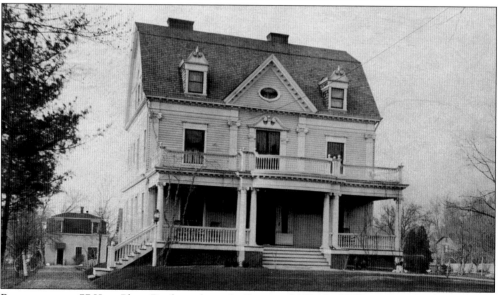

Breezemont, at 77 Kent Place Boulevard, was built around 1894 for William F. Bailey (1836–1906) of the Newark lumber firm Bailey & Alling. Bailey moved to Summit in about 1889, was active in the Baptist church, and was deemed "one of the oldest and most influential citizens of Summit" upon his death. Breezemont was often leased during the summer. Today, it is in poor condition and missing many of its original architectural details.

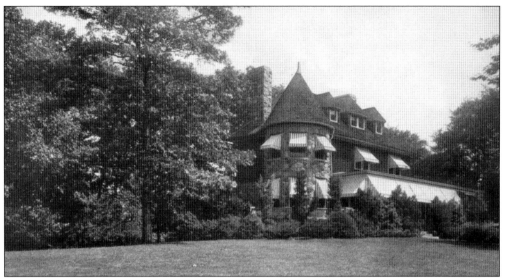

Edgemont, at 15 Badeau Avenue, was built in 1893 for William E. Badeau (1853–1932), the head of a New York stationery firm. Badeau moved to Summit in the mid-1880s and acquired considerable property. In his *History of Union County, New Jersey*, Frederick W. Ricord describes Badeau as "conspicuously identified with the development and substantial upbuilding of the attractive town. His investments in local realty give evidence of keen foresight and rare judgment as to intrinsic values."

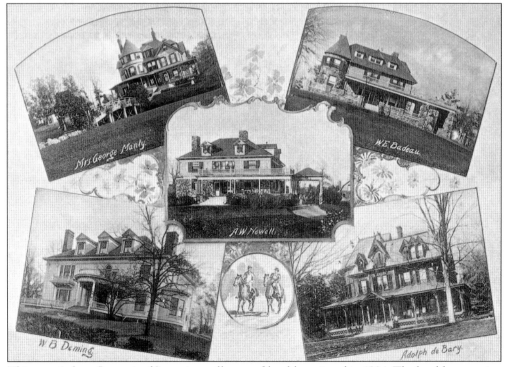

This page is from *Souvenir of Summit*, an illustrated booklet printed in 1894. The booklet contains photographs of scenic spots, various buildings, and the residences of prominent citizens such as those illustrated here. Note the photograph of William Badeau's home in the upper right corner.

57

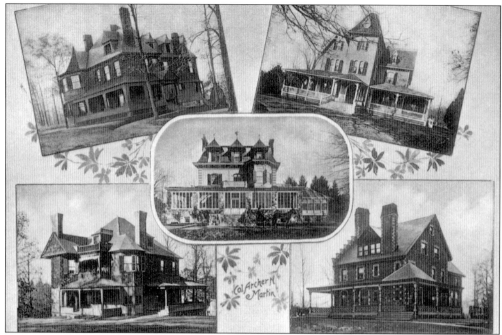

Seen here are two more pages from the 1894 *Souvenir of Summit* booklet. These pages showcase the following residences: 21 Edgewood Road (Parker W. Page), 11 Edgewood Road (Edmund Schwartze), 86 Hobart Avenue (Charles E. Bulkley), 160 Kent Place Boulevard (George W. Dillingham), Nuthurst, at 65 Norwood Avenue (Col. Archer N. Martin), 185 Springfield Avenue (Gustav Amsinck), 619 Springfield Avenue (William Cranstoun), 44 Blackburn Road (William Z. Larned), 535 Springfield Avenue (Dr. William H. Risk), and 97 Prospect Street (Norman Schultz).

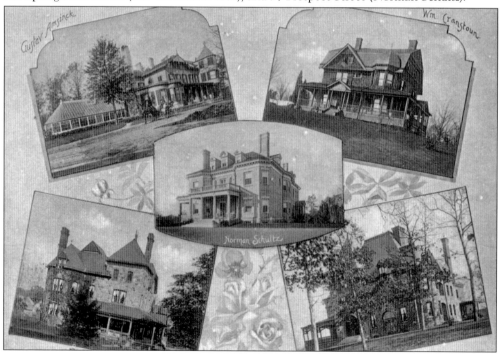

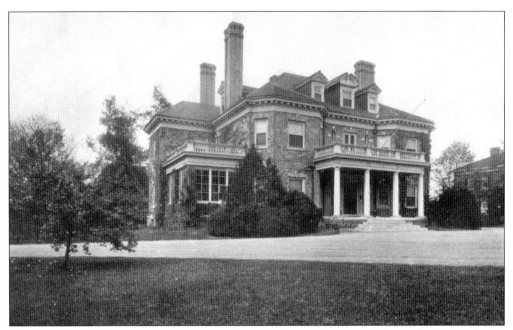

This home, at 97 Prospect Street, is one of the residences featured in *Souvenir of Summit*. No longer standing, it was built around 1893 for Norman H. Schultz, an executive with the United States Leather Company in New York, on a lot he purchased from William H. DeForest. Sadly, Schultz died in 1918 while traveling to New York on the Lackawanna ferry.

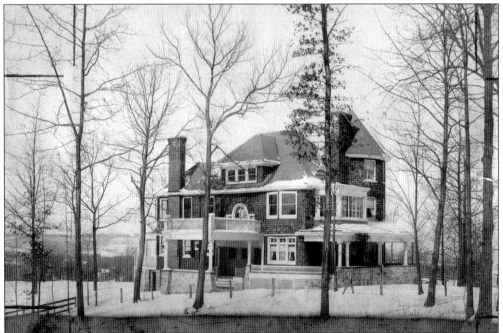

Sunset once stood at 2 Beekman Road and was built around 1895 for William Halls Jr., a New York banker and, for many years, the chairman of the board of the Summit Trust Company. Halls and his family first came to Summit in 1889 for the benefit of his health. He lived here until 1924. In 1910, George H. Whittaker, his wife's brother, built a house next door at 56 High Street.

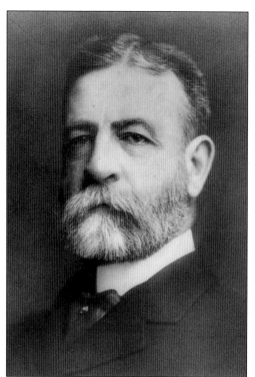

William J. Curtis (1854–1927), a prominent attorney with Sullivan & Cromwell in New York, was so impressed with Summit while visiting his friend Augustus F. Libby that he resolved to move here after his marriage. True to his word, Curtis arrived with his bride in 1881, staying at Blackburn House until moving into a new home on Springfield Avenue. From 1884 to 1896, they resided at 196 Kent Place Boulevard.

In 1896, William J. Curtis moved his family from their more modest home on Kent Place Boulevard to Fairfax, the grand residence he built at 37 Ridge Road. In his memoirs, Curtis discloses that the Connecticut Building at the 1893 Chicago World's Fair was the inspiration for his home's Colonial architectural style. While Fairfax is no longer standing, the estate's carriage house and gardener's cottage are now residences.

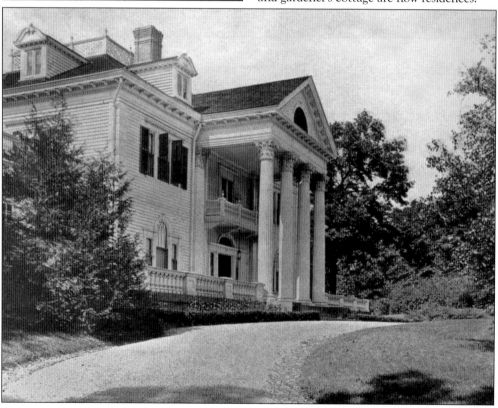

Tired of New York City apartment living, attorney Frank Lindsay Crawford (1856–1950) moved his family to Summit in 1889. He described living conditions here at that time as "rather primitive." Along with William J. Curtis, he was one of the founders of Kent Place School in 1894.

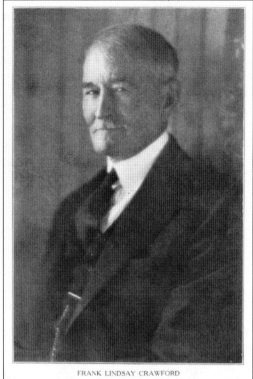

FRANK LINDSAY CRAWFORD

Crawford built this house, designed by Jardine, Kent & Jardine, at 24 Ridge Road in 1896. On January 30, 1897, the *Summit Record* reported, "The handsome new home on Fernwood Road, into which Mr. F. L. Crawford and family removed a few weeks ago, has been appropriately named 'Four Winds,' because its commanding position renders it a shining mark for the wind from every direction."

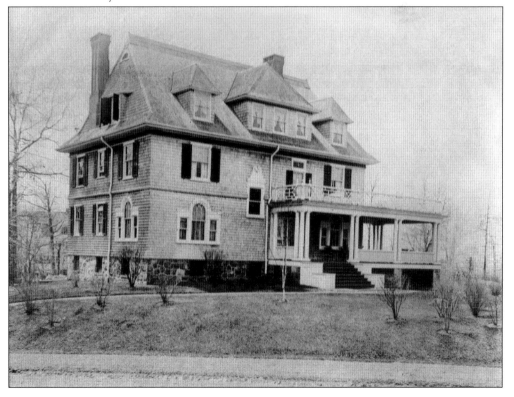

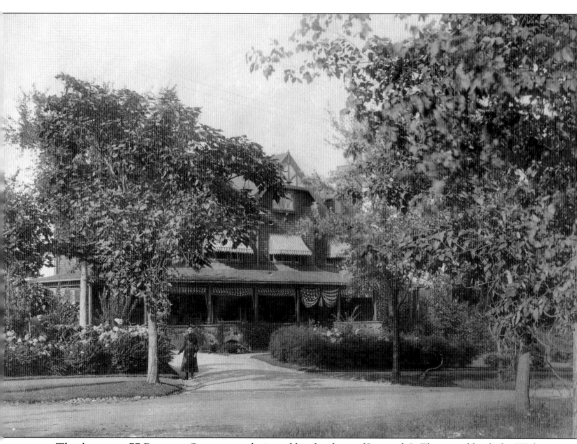

This home, at 77 Prospect Street, was designed by the firm of Larned & Flagg and built for Walter Dean Briggs (1854–1915), a wealthy merchant in the woolen business in New York. The Briggs family first came to Summit in the early 1890s. They spent several summers at Blackburn House and leased houses here in the winter before deciding to build their own home. In October 1898, the *Summit Record* announced, "The beautiful massive home for W. D. Briggs and family on which workers have been employed for several months has at last been completed." The Briggs estate stretched along Blackburn Road from Locust Drive to Prospect Street and down Prospect Street from Blackburn Road to Brayton Brook. Although the property has been subdivided, the house, although now without its generous front porch, still presides over the corner of Prospect Street and Blackburn Road.

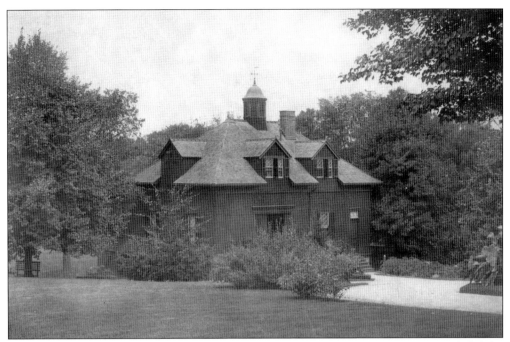

Walter Dean Briggs was known for his love of horses and fine coaches, and his estate included the spacious carriage house above. In pursuit of his passion, Briggs served as the vice president of the Morristown Horse Show and won several prizes there. His carriage house is now the residence at 30 Blackburn Road. The photograph below of the interior of 77 Prospect Street reveals that the home was fashionably furnished in the eclectic decorating style popular around 1900.

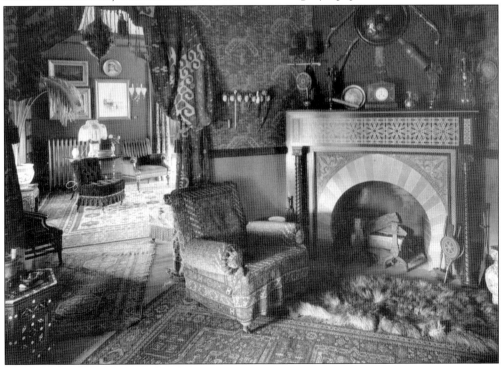

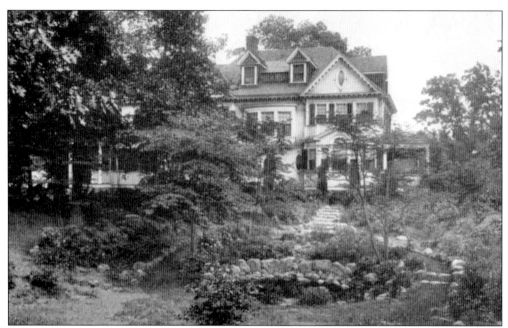

Ludleigh, at 133 Hobart Road, was designed by local architect Richard S. Shapter and built for Frank Azer Dillingham (1869–1941) on land he purchased in 1898. Dillingham, a successful New York lawyer, was the son of George W. Dillingham. He lived here until moving to Millburn in about 1910.

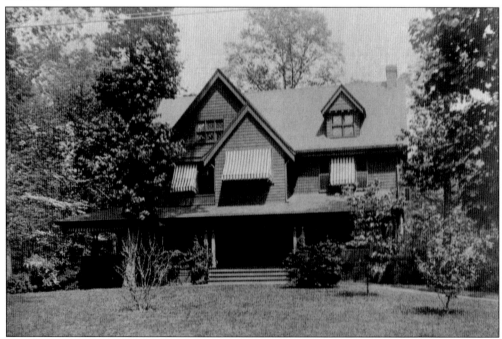

In July 1900, William Warren Carman (1869–1952) and his family moved into their new home at 85 Hobart Avenue. Carman was associated with Arthur Curtiss James, a wealthy railroad industrialist. After James's death, Carman served as the executor of the $35 million James estate and as president of the James Foundation, a charitable organization in New York.

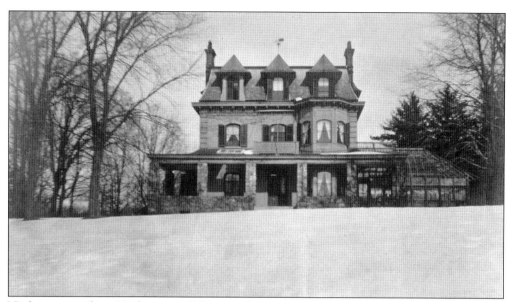

No longer standing, Nuthurst, at 65 Norwood Avenue, was the residence of Theodore Berdell (1844–1901). According to his obituary in the *New York Times* on December 31, 1901, Berdell was one of Summit's wealthiest residents, having amassed a fortune through an invention for smelting ores and as a major stockholder in the American Smelting & Refining Company. The Berdell family came to Summit in 1894 and leased Cloverpatch, at 212 Kent Place Boulevard, before acquiring and renovating this house, part of the Col. Archer Martin estate, in about 1899. As evidenced by the photograph below, the home's grounds were beautifully landscaped.

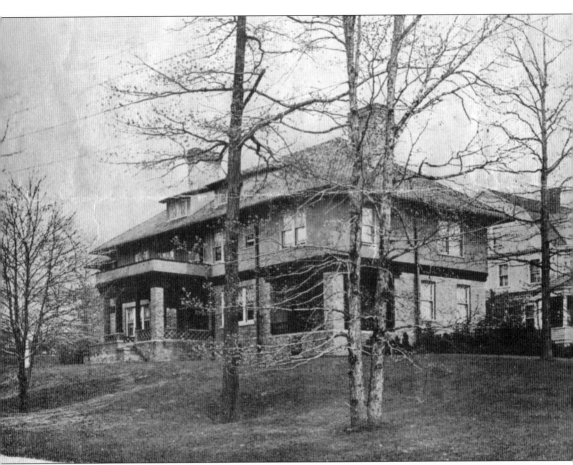

Designed by the New York architectural firm of Brite & Bacon, this home at 26 Ridge Road was built for Henry A. LaFetra (1837–1922), an industrialist with the Royal Baking Powder Company. An article in the October 15, 1898, *Summit Record* notes, "For about twelve years Mr. H. A. LaFetra has been one of the regular summer visitors to Summit and found so many attractions here as a place of residence that he determined several years ago to establish a permanent home at the earliest opportunity." The article goes on to announce that LaFetra has purchased a lot from Dr. William H. Risk across from the William J. Curtis residence at 37 Ridge Road, and intends to build a home there. Completed in 1900, Laffield House—combining LaFetra and Fields, his wife's maiden name—served as the LaFetra family's summer residence.

Five

An Ideal
Suburban Hometown
1900–1910

Summit's population continued to grow, increasing from 5,302 inhabitants in 1900 to 6,845 in 1905. But even as more residents became full-time, summer rentals remained popular. According to the April 12, 1902, *Summit Record*:

> The demand for homes in Summit for the summer continues to be unusual, and the list of those who have already secured residences include a large number who have heretofore been only occasional visitors here, but have found healthfulness and general advantages sufficient to induce them to spend the entire season this year.

In the fall, after spending the summer elsewhere, those residents who had leased their homes would return, as evidenced by this comment in an October 1904 issue of the *Summit Herald*: "We are always glad to greet our old residents who return to Summit after a summer spent at the mountains or seashore, or upon the continent."

In 1902, the Delaware, Lackawanna & Western Railroad undertook a huge improvement project. In Summit, this entailed depressing tracks in the center of town, relocating some tracks, and building a new station. The work was completed in 1905.

Development continued apace. The July 6, 1907, front page of the *Summit Herald* notes, "There is no indication of slack times in the construction of new buildings in Summit." Even the *New York Times* took note, reporting on March 14, 1909, in an article titled "Much Building In Summit: Many New Yorkers Erecting Homes in New Jersey's 'Hill City'" that at least 40 residences were under construction, making this "one of the greatest periods of building activity this place, the 'Hill City,' has known."

One notable real estate transaction during this period was the 1910 sale of the 100-acre Oliver J. Hayes estate to a group of investors who planned to develop it into an exclusive residential section. Other tracts were being developed into the Beechwood Park, Ridge Crest, and Edgemont neighborhoods. *Summit New Jersey – The Hill City – An Ideal Suburban Home Town*, a brochure published in 1909, makes the prediction that "in the next ten years, Summit will probably double in population."

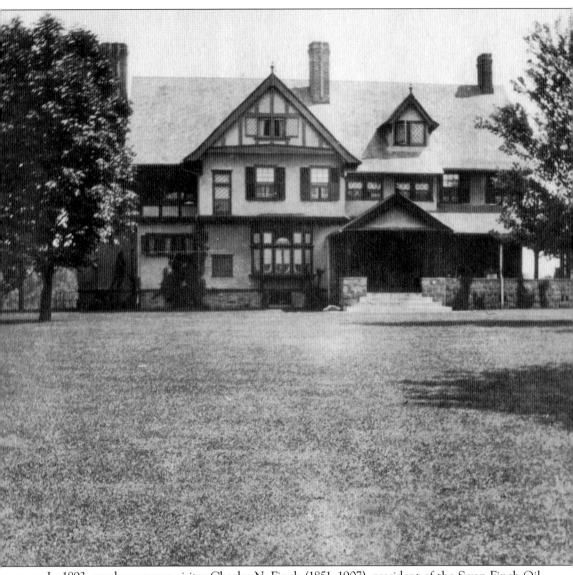

In 1893, regular summer visitor Charles N. Finch (1851–1907), president of the Swan-Finch Oil Company in New York, purchased a large lot from Augustus F. Libby adjoining Libby's estate, Finisterre, on Beekman Terrace. Although Finch and his family continued to spend summers in Summit, they did not immediately build on their new property. When they did decide to build, the Finchs chose Rossiter & Wright, the same architectural firm that designed Libby's residence, to plan their new home. In October 1900, the *Summit Herald* announced, "Charles N. Finch and family, who have been at the Park House, expect to move into their handsome new residence on Beekman road [sic] next week." Their home, Ingleside, still standing at 36 Beekman Terrace, is seen here in 1925. Finch served on common council and on the board of education.

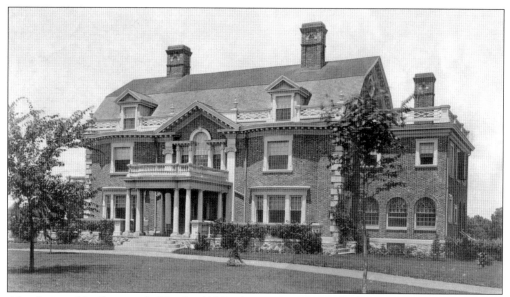

Also designed by Rossiter & Wright, 111 Beekman Terrace was built in 1901 for Robert S. Holt (1831–1905) of Holt & Company, New York flour merchants. Like his neighbor Charles Finch, Holt was a regular summer visitor who purchased a lot from Augustus F. Libby. The house was called Vidablick when it was owned by Elmer Underwood from around 1910 to 1923, and then renamed Wendeldora when Wheatena president Arthur R. Wendell owned it from 1923 to 1952.

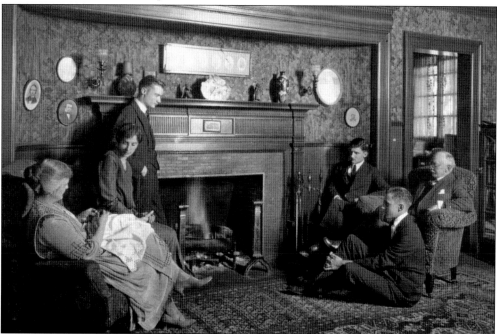

This photograph, taken on Christmas Day 1921, shows the Underwood family in the living room of 111 Beekman Terrace. They are, from left to right, Jane (sewing), Ruth, Charles, Orvis, John (on floor), and Elmer Underwood. Elmer and his brother Bert, who lived at 85 Prospect Street, were the founders of Underwood & Underwood, an internationally renowned commercial photography firm. (Courtesy of Julie Lynch.)

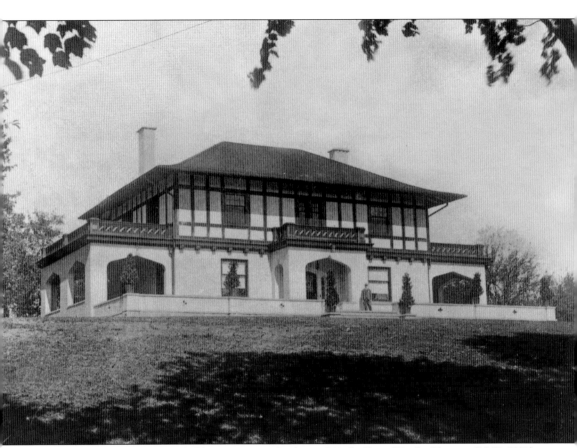

This home, at 695 Springfield Avenue, was built in 1901 for David Leslie Youngs (1867–1921), a New York lumber merchant. In a 1901 article in the *Summit Herald*, architect William K. Benedict explains the house's unusual appearance: "The lines of the house express the motif suggested by this natural condition of the site . . . The one object of the design is to create an effect with simplicity of lines and proper massing of features and shadows. The coloring is in harmony with the landscape, the style of the house being an adaptation of the California mission style and half timber." Youngs and his family moved to this house from Brooklyn, but they had deep Summit connections. At the time Youngs moved here, his aunt Mary J. Youngs, the widow of early Summit resident David Addison Youngs, was living at 666 Springfield Avenue, his cousin David Arthur Youngs had just built a home at 674 Springfield Avenue, and his father-in-law Joel G. Van Cise was living next door at 701 Springfield Avenue.

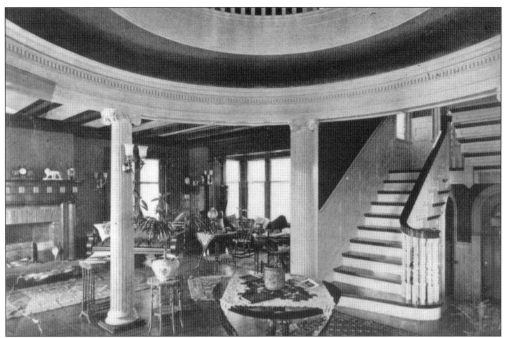

These photographs show the unusual circular entry hall of 695 Springfield Avenue. The house was known for its woodwork and featured a different wood in each room. This was not surprising given that owner David Leslie Youngs was in the lumber business. Note the elaborate spindles on the staircase railing. The May 11, 1901, *Summit Herald* reports that the D.L. Youngs family had moved into their new Springfield Avenue home and notes that it is "of a unique design" and "handsomely furnished inside." Today, the house, without some of its original exterior details, serves as the headquarters for the local chapter of the American Red Cross.

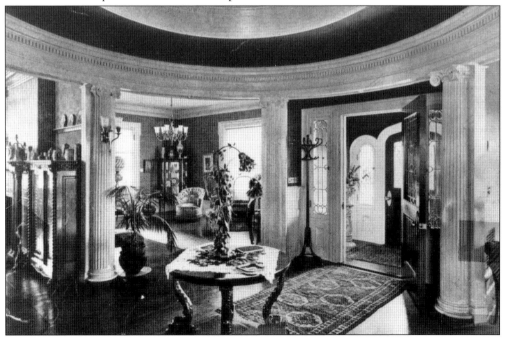

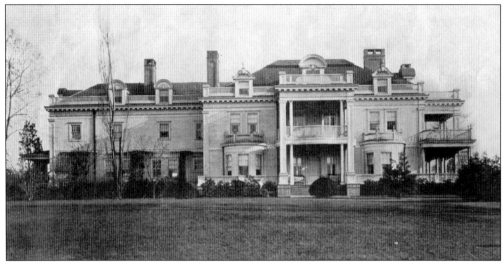

In 1899, the *Summit Record* reported that James W. Cromwell was about to build "a magnificent residence" on Beekman Road and predicted, "When completed it will be one of the most imposing and spacious homes in Summit." A summer visitor since 1885, Cromwell (1842–1932) was a wealthy New York merchant prominent in the textile trade. Finished in 1900, this house stood on 14 acres where Cromwell Parkway is today. Cromwell's son, James W. Cromwell Jr., was the architect.

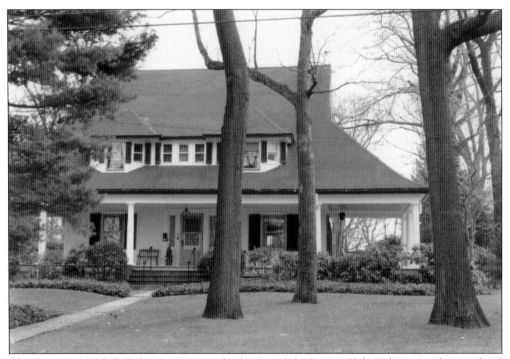

This home, at 60 Oak Ridge Avenue, was built in 1902 for Louisa Holt Colton, a widow, on land acquired from her brother Philetus Havens Holt (1867–1947). Shortly afterwards, Holt built his own home at 70 Oak Ridge Avenue. James W. Cromwell Jr. designed both houses. Holt and his brother Robert S. Holt, of Beekman Terrace, were associated with their family's New York flour business, Holt & Company.

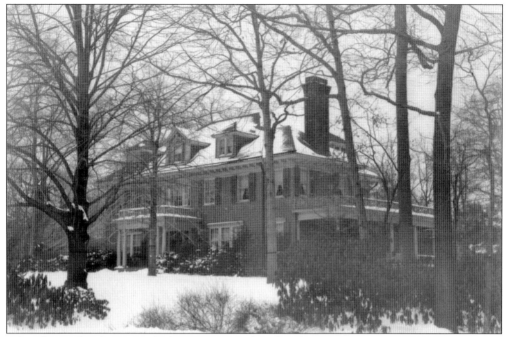

Edward Benedict (1856–1941), the treasurer of the Thatcher Furnace Company in Newark, built this house at 41 Whittredge Road in 1902. When the Benedicts put it up for sale in 1911, it was advertised in *Country Life in America* as having fourteen rooms, three bathrooms, one acre of land, and a garage. In 1925, the house, then owned by Amedee Spadone, was showcased in the *Summit Herald*'s illustrated supplement.

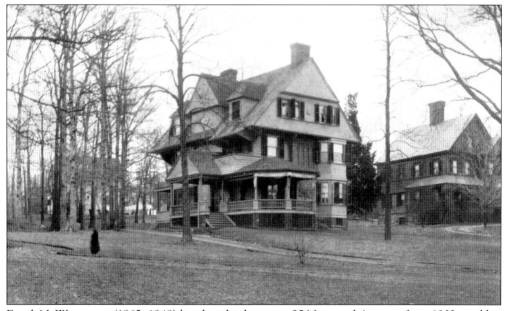

Frank N. Waterman (1865–1948) lived in this home, at 25 Norwood Avenue, from 1902 until his death. Waterman was an engineering consultant involved in many of the early patent cases for major electric and radio companies and an active member of several Summit men's organizations. The house was demolished in 2000 to make way for condominiums.

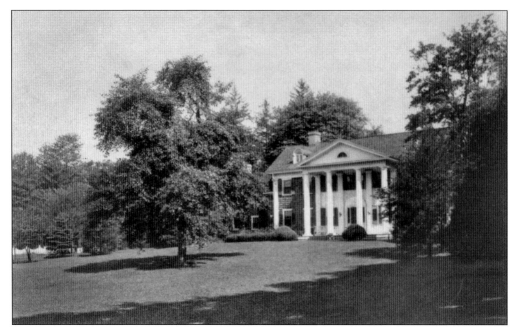

Dalkeith, at 683 Springfield Avenue, was erected in 1903 for Robert Cade Wilson, a noted magazine publisher. Wilson, observes the November 15, 1902, *Summit Record*, "found Summit so delightful and healthful that he will reside here permanently." The house is no longer standing. Through negotiations with the Wilson estate, the City of Summit eventually acquired the property, which is now home to Wilson School and Wilson Park.

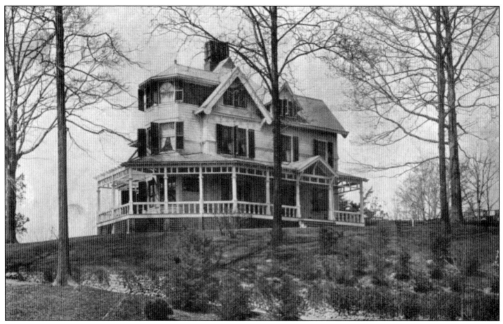

Seen here in 1914, this home, at 41 Prospect Street, belonged to William Lyall (1840–1916). Lyall owned cotton mills in Passaic and served a term on common council. Since demolished, the house was constructed in 1903 and designed by Lyall's son Earl, an architect who also designed Summit's Carnegie library building in 1911.

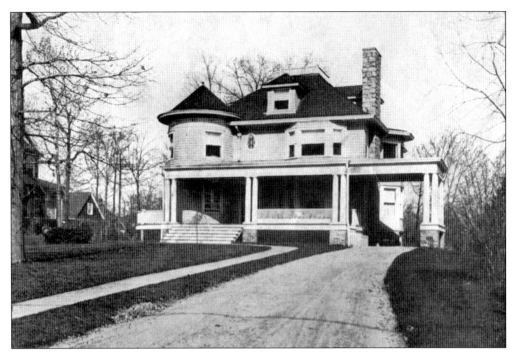

This house, seen here in 1914, was built around 1903 at 173 Summit Avenue for Charles D. Ferry (1868–1961) of the Newark-based Ferry Hat Manufacturing Company. Ferry, a member of common council from 1907 to 1912, lived here until 1916, when he moved to 271 Kent Place Boulevard, the former home of his father, George J. Ferry.

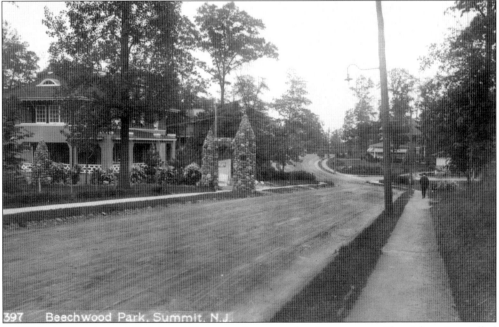

In 1906, the Beechwood Park Land Company began to develop a new residential section called Beechwood Park. This photograph shows the development in about 1911. Beechwood Park contained 37 building lots on Beechwood Road and the newly opened Hawthorne Place.

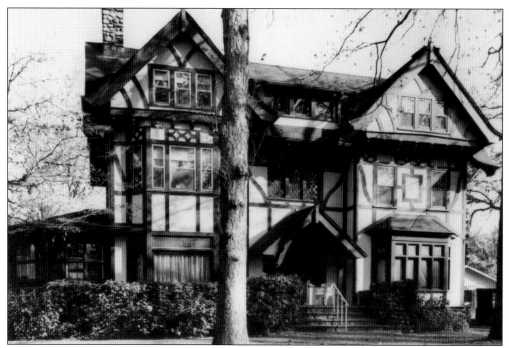

This house, at 23 Crescent Avenue, was built in 1904 for William Hyde Wheeler, a New York stockbroker. Before building their home, Wheeler and his wife were guests at the Blackburn House for many years. After his wife's untimely death in 1910, Wheeler remarried and lived at 31 Hillcrest Avenue.

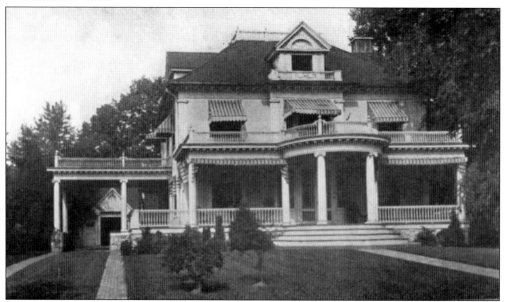

This home, at 18 Hobart Avenue, was the residence of George F. Vreeland (1866–1916), a New York businessman who served on common council and as mayor. The December 10, 1904, *Summit Herald* reports, "One of the handsomest, most up-to-date and thoroughly built houses in Summit has just been completed by Architect W. Allan Balch, for Councilman George F. Vreeland on Hobart avenue. The workmanship through out is of the highest mechanical skill."

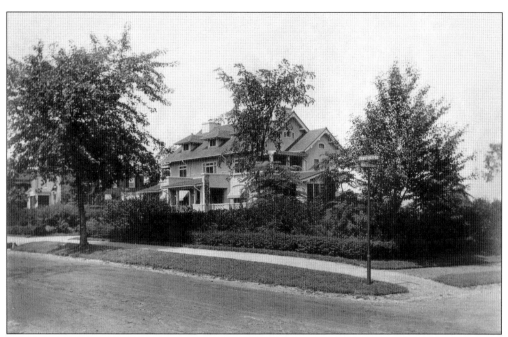

Also designed by architect William A. Balch, 85 Prospect Street, seen above, was erected in about 1906 for Bert Elias Underwood (1862–1943), the brother of Elmer Underwood, of 111 Beekman Terrace. The brothers founded the photographic firm of Underwood & Underwood, which was at one time the largest publisher of stereoviews in the world, producing more than 10 million views a year. They moved their business to New York in 1891. The photograph below shows the home (right) under construction in 1906. Also visible are the Norman Schultz residence, at 97 Prospect Street (far left), and the Harry H. Gifford residence, at 91 Prospect Street.

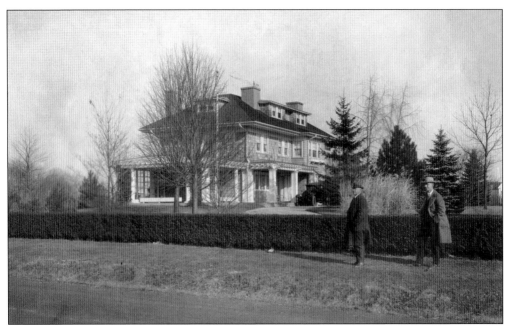

The house above, at 271 Kent Place Boulevard, was constructed in 1907. For many years, it was the only house at this end of the street, as seen below. Originally located slightly east of its present location, it was built for George J. Ferry (1830–1916), a successful Newark hat manufacturer. Ferry moved to Summit to be near his son Charles, who lived at 173 Summit Avenue. After his father's death, Charles D. Ferry (1868–1961), a councilman from 1907 to 1912, moved to this house. When he put it up for sale, a listing in *The Outlook* on February 16, 1921, announced, "For Sale – Summit, N. J. Beautiful corner lot . . . overlooking Passaic Valley and surrounding country. Shingle house, thirteen rooms, three baths; hot water heat; three-car garage; asparagus bed, fruit trees, grape vines, flowering plants and shrubbery in abundance."

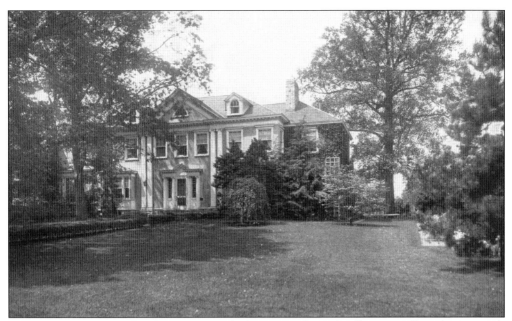

Greenock, at 100 Woodland Avenue, was built in 1906 for Col. Allan B. Wallace (1863–1938). A Spanish-American War veteran, Wallace was associated with the J.C. Smith & Wallace Company, Newark grain merchants, and came to Summit in 1893. He served for several years on the board of health and resided here until his death. The house was renamed Ruth-Haven when J.W. Rahde purchased it in 1954.

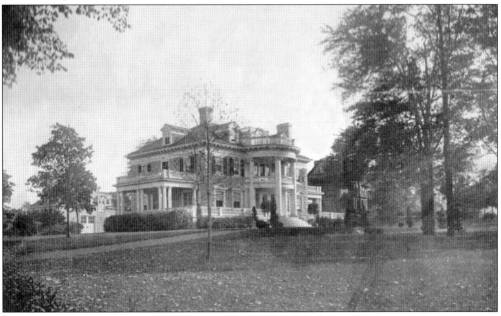

Listed in the National Register of Historic Places, Twin Maples, at 214 Springfield Avenue, was designed by Alfred F. Norris and built in 1908 for New York attorney James C. Foley (1845–1916). While Foley never held public office, his obituary notes, "He had an unusually deep interest in all questions that concerned the city." Today, the house serves as the headquarters for the Fortnightly Club.

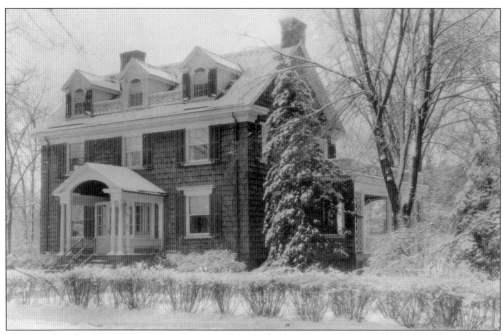

In 1907, shortly after retiring, Augustus F. Libby built this house, designed by Richard S. Shapter, at 80 Prospect Street on a lot purchased from William Z. Larned. As these photographs show, this home was significantly more modest, inside and out, than Finisterre, the Libbys' previous residence at 40 Beekman Terrace. Active in Summit affairs, Libby served on the board of education and the library's board of trustees and belonged to several clubs. He resided here with his wife and daughter from 1909 until his death in 1919. After her mother died in 1931, Marie C. Libby continued living here until she sold the house in 1939. (Both, courtesy of Jack and Millie Cooper.)

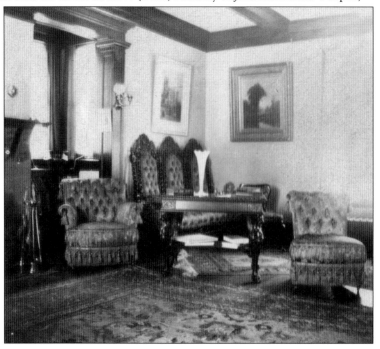

This home, at 200 Kent Place Boulevard, was built in 1909 for Walter Harper Collins, the founder and president of the W.H. Collins Company in New York. The June 26, 1909, *Summit Herald* reports that, until he could realize plans to build a Fresh Air Home for 20 children, Collins would be using his new barn. From 1945 to 1960, Perry M. Shoemaker, the president of the Delaware, Lackawanna & Western Railroad, lived here.

Designed by Balch & Moatz, Inwood, at 64 Prospect Street, was built in about 1909 for Edwin Scott Votey (1856–1931), the inventor of the pianola and the founder of the Aeolian Company. Pianolas were produced in Garwood, which may have prompted Votey's move to Summit around 1900. Votey served on common council from 1904 to 1906.

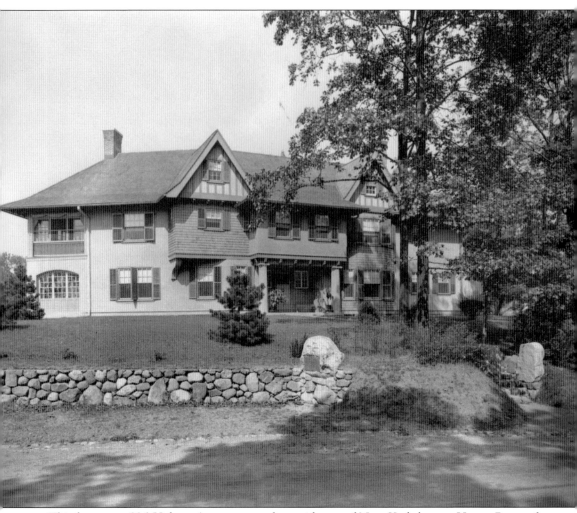

This house, at 226 Hobart Avenue, was the residence of New York lawyer Henry Bancroft Twombly and his family from 1908 to 1955. It was designed and built by the local firm of Kelly & Boland. The Twomblys moved to Summit shortly after their marriage in 1889. They built their first home at 32 Woodland Avenue and resided there until 1908, when they moved into this more commodious residence. The April 20, 1907, issue of the *Summit Herald* notes that H.B. Twombly had purchased a "historical piece of property" and that his new house was under construction. A boulder marking the site of Summit's Revolutionary War signal beacon is embedded in the stone wall along the street side of the house's property. It was moved there from another spot in the yard when the Twomblys built their home.

Henry B. Twombly (1863–1955) was a lawyer with the New York firm of Twombly & Putney and was involved with the incorporation of such leading firms as the General Electric Company and the Otis Elevator Company. In 1949, he was honored by the Lackawanna Railroad for 60 years of commuting. In Summit, Twombly was involved in many civic activities, including the Neighborhood House, the YMCA, and the board of health. His wife, Frances Doane Twombly (1860–1942), was also civically active, with a particular interest in public recreation. She helped found the Neighborhood House and develop Soldiers' Memorial Field. Their son Edward B. Twombly served as Summit's mayor. Mr. and Mrs. Twombly (seated center) are seen below with their family on their 50th wedding anniversary.

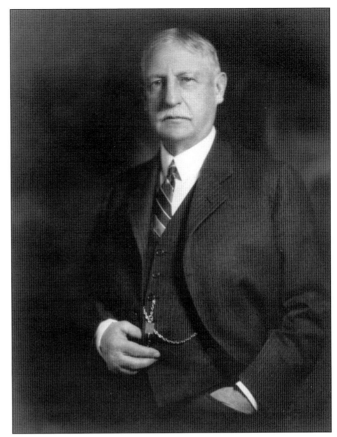

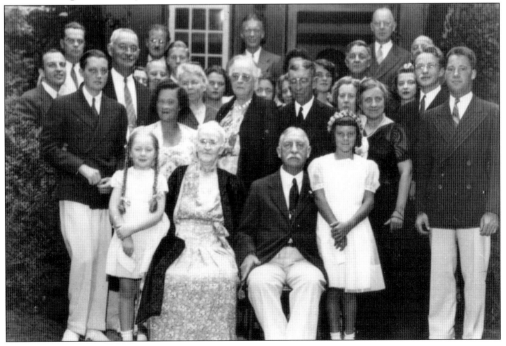

Summit, New Jersey – The Hill City – An Ideal Suburban Home Town, a brochure published in 1909, showcases the homes of prominent citizens and promotes the town's benefits. It notes, "The quiet restfulness of its environments and its convenience to New York, has attracted to Summit an interesting and substantial class of residents . . . Summit is chosen by a great many as a place of abode because of its accessibility to nearby cities and towns, up-to-date hotels and boarding houses, its schools and churches, its athletics and other out-of-door amusements, its diversified walks and drives, and most of all, for its climate and pure water supply."

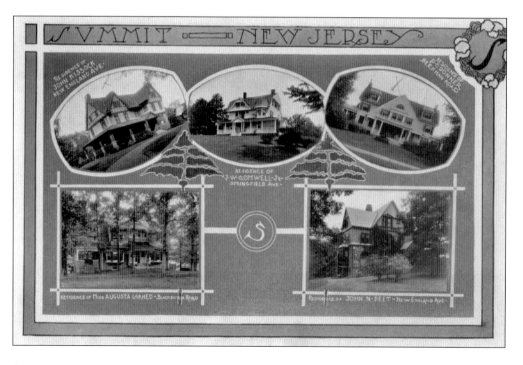

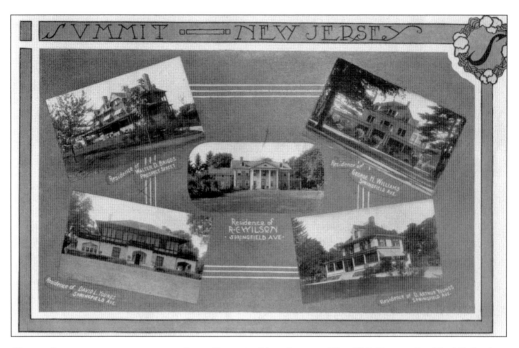

Shown here are two more pages from *Summit, New Jersey – The Hill City – An Ideal Suburban Home Town*. The publication also emphasizes the health benefits of the town: "The dry air and hygienic surroundings have made Summit famous as a health resort . . . Absolute freedom from malaria is one of the characteristics of the place that appeals to all homeseekers." To further underscore Summit's attractiveness, the brochure points out, "Many who have come here for a brief summer's stay have been so captivated by its charms that they have located here permanently. Summit is essentially a place of homes."

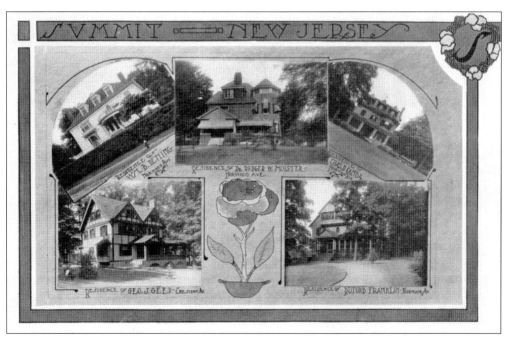

The Tudor Revival home above, at 27 Beekman Terrace, was built on part of Augustus F. Libby's former estate in about 1909 for Gardner Pattison. At the time of his death in 1947, Pattison was the president and director of Burns Brothers, one of the largest coal companies in New York. The Pattison family lived here until about 1925, when they moved to Short Hills. On the page below, from the 1909 promotional brochure, *Summit, New Jersey – The Hill City – An Ideal Suburban Home Town*, the house appears in the lower right corner.

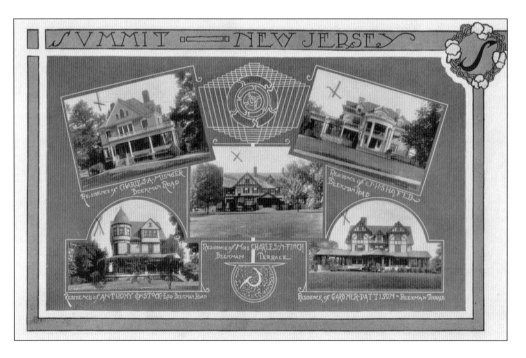

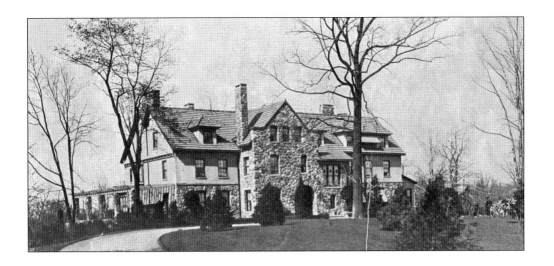

Serving as the Beacon Hill Club since 1956, the house above, at 250 Hobart Avenue, was built in 1909–1910 for Carroll Phillips Bassett (1863–1952). Seen here in 1914, Beacon Hill was designed by renowned Maine architect John Calvin Stevens and his son John Howard Stevens. Its beautifully landscaped grounds, seen below in 1925, reflected the interests of Bassett's wife, Margaret, the founder of the Summit Garden Club. Landscape architect Martha Brooks Hutcheson designed one of the original terraced gardens. Bassett moved to Summit in 1887 and played a leading role in its financial, political, and business affairs. A civil engineer, he designed Summit's water supply system, helped organize its first electrical franchise, supervised construction of its sewer system, served as the town engineer, and financed and managed several public utilities.

Built in 1910, this home, at 45 Bellevue Avenue, was designed by well-known local architect Joy Wheeler Dow (1860–1937), who lived here until about 1920. Dow worked primarily in New Jersey. In Summit, he also designed Kingdor, at 18 Badeau Avenue, Silvergate, at 21 Badeau Avenue, and the Unitarian church on Springfield Avenue.

Seen here in 1925, this home, at 81 Oak Ridge Avenue, was built for Albert George Scherer, a successful Newark businessman in the leather manufacturing business. A March 13, 1910, *New York Times* article titled "Attractions Of Summit" notes that Scherer had purchased a large property on Oak Ridge and would be erecting a $30,000 residence.

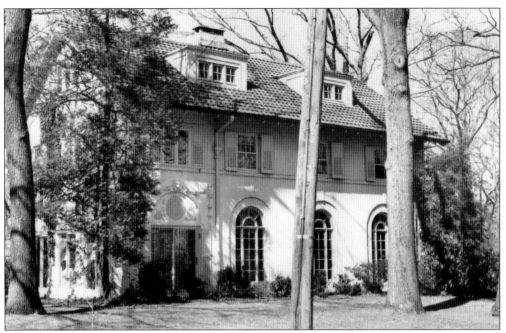

Perry R. MacNeille of the New York architectural firm Mann & MacNeille was one of the developers of Ridge Crest. In 1910, he built his personal residence, seen here, at 141 Oak Ridge Avenue, where he lived until his death in 1931. The house is featured in the 1914 *Year Book of the Architectural League of New York*. A strong advocate of city planning, MacNeille served as the president of Summit's first planning commission.

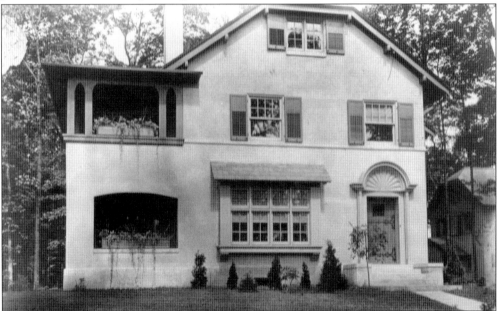

This home, at 125 Oak Ridge Avenue, was built around 1910 on one of the lots that made up the Ridge Crest development on Oak Ridge and Mountain Avenues. In a November 1910 issue, the *Summit Herald* reports that 22 of the 26 lots had been sold and that six "elegant fire-proof houses" were nearing completion under the supervision of Mann & MacNeille.

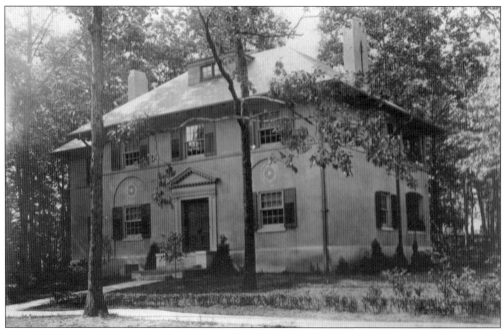

Also part of the Ridge Crest development, this house at 1 Primrose Place is one of the homes featured in the 1925 illustrated supplement of the *Summit Herald*. It was the residence of Herbert Clark Gilson (1878–1943), a Jersey City lawyer, from about the time of his marriage, in 1915, until 1923.

Summit architect Richard S. Shapter designed this home at 67 Oak Ridge Avenue for Abram B. Kolyer, the president of a New York wholesale plumbing supply company and a charter member of Summit's old guard. Built in 1910, it too appears in the *Summit Herald*'s 1925 supplement. Kolyer resided here until his death in 1942.

Six

WAR YEARS
1910–1920

In 1910, Summit's population reached 7,500. Local newspapers continued to publish lists of summer rentals, but more attention was now given to mentioning what vacation spots residents were visiting as travel by car became more prevalent. Summit's ongoing appeal to city dwellers is captured in this passage from a 1913 brochure extolling the virtues of two new developments, Prospect Hill and Canoe Brook Estates:

> As home life in the city grows increasingly difficult and expensive, improved transit facilities are making the country more and more convenient, and the use of the automobile is making it more and more of a pleasure . . . If your office is with the 'cliff dwellers'; if your families live in city blocks or in the tiny rooms of an apartment hotel, and your children are deprived of the outdoor life which alone can give them the pink cheeks and redundant spirits of perfect health; if you are yourself finding life growing more and more strenuous and feel the need of a change of scene each night, and the rest and quiet of a country house; if you would like to ride home in absolute comfort, with each passenger seated, with good light, and a journey just long enough to read your paper; and particularly if you wish to come home to ideal country surroundings, beautiful and healthful, and with an outlook from your dinner table, a perusal of this book is respectfully suggested.

Development of both large houses and residential neighborhoods continued. An illustrated supplement to the *Summit Herald* on May 22, 1914, features the impressive homes of prominent residents, most of whom had professional ties to New York. In 1916, just before the United States entered World War I, local papers reported several large real estate transactions and increased building activity. One article notes, "The number of buildings now in progress, the repair work on homes in every section of the city and the plans in contemplation promise a summer and fall of activity that will be very welcome to contractors who have had two or three years of unusual depression."

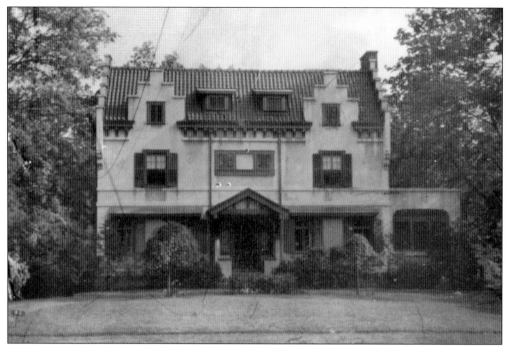

When completed in 1911, this home, at 92 Prospect Street, was featured in the *Summit Herald* and described as "an adaptation to American requirements of early Dutch architecture" with an exterior "as nearly as possible, the counterpart of an early New Amsterdam house," and interior details adapted from old Dutch paintings and engravings.

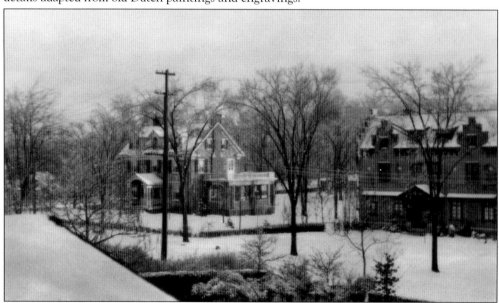

92 Prospect Street is also seen on the right in this 1915 photograph. It was the home of New York attorney Herbert J. Lyall and was designed by his brother, architect Earl Harvey Lyall, who also designed Summit's 1911 library building. Their father, William Lyall, was an early Summit resident and commuter who served on common council. On the left is 80 Prospect Street, the Augustus F. Libby residence. (Courtesy of Jack and Millie Cooper.)

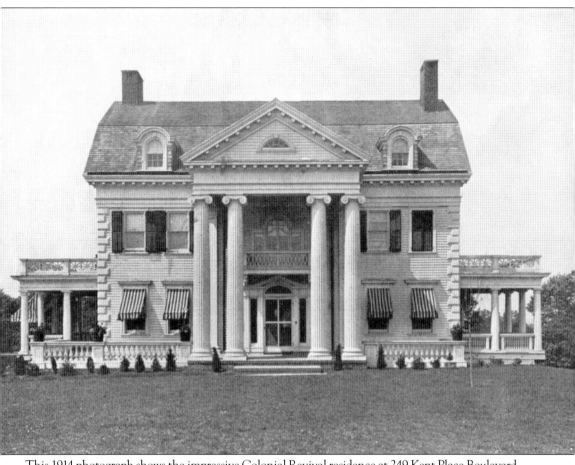

This 1914 photograph shows the impressive Colonial Revival residence at 249 Kent Place Boulevard. The house was built around 1911 by George H. Williams (1849–1921) for his daughter Ada and her husband, Frederick N. Cowperthwait, a New York insurance broker. Williams, who resided at 768 Springfield Avenue, erected several other houses in Summit. He is described in his obituary as "a large property holder in the western end of the city" who "did a great deal in developing that section with buildings on Springfield avenue, and the opening of Sunset drive and building seven attractive homes thereon." The Cowperthwaits raised their family in this home. Family members continued to reside in the house until the late 1940s.

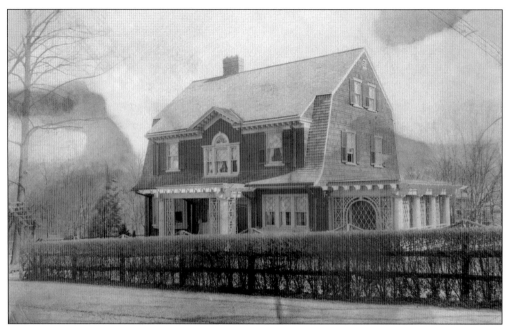

When his daughter Helen Louise married Norman L. Swartout in 1911, William D. Briggs built the newlyweds a house at 24 Blackburn Road, behind the Briggs home at 77 Prospect Street. The house was called The Paddock because it was built behind the coach house in the field where the horses used to graze.

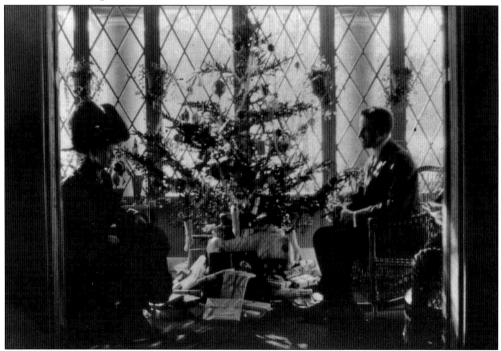

Seen here in their home at 24 Blackburn Road are Mr. and Mrs. Norman L. Swartout, celebrating what may have been their first Christmas there. The Swartouts founded the Summit Playhouse Association. (Courtesy of Ann Houpt.)

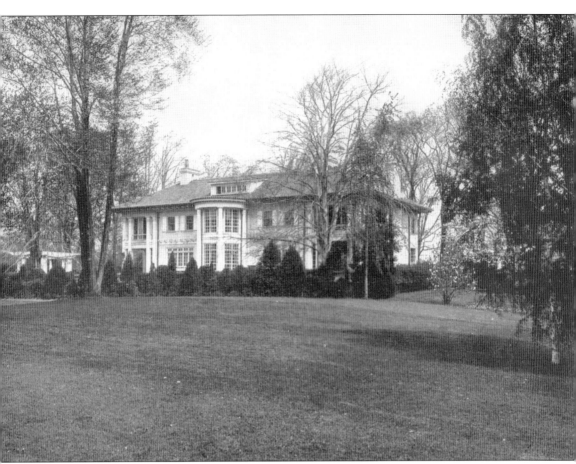

Twin Beeches, at 215 (now 233) Springfield Avenue, was built in 1912–1913 on property that was once part of the Oliver Hayes estate. Originally the home of Alexander R. Nicol, an executive with the Atlantic, Gulf & West Indies Steamship Company in New York, it is among the residences showcased in the *Summit Herald*'s 1914 illustrated supplement. Named for the two purple beeches that flanked its entrance, the property once boasted 52 varieties of trees, many of them imported from China, Japan, and other countries. Nicol sold the property in 1924 to Charles H. Ault, a Newark businessman. The *Summit Herald* chose to showcase the house again in its 1925 supplement. An undated real estate brochure for the house cites the benefits of its location in Summit, "a City of distinctive homes, located on the crest of Watchung Mountains," and the "convenient commute." It also mentions that "absolute freedom from malaria, recommends it as being the most healthful Suburb within a reasonable commuting distance of New York."

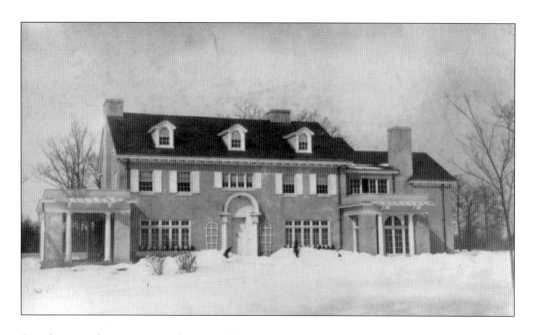

Seen here are the gracious residence and beautifully landscaped grounds at 70 Hillcrest Avenue. The house was designed by Balch & Beardsley and built in 1912 for C.H.C. Jagels (1870–1945), at that time the treasurer of Jagels & Bellis, coal merchants based in Hoboken. In 1914, it was featured in the *Summit Herald*'s illustrated supplement. Active in the business communities of both Hoboken and Summit, Jagels served on the boards of several banks, invested in and developed real estate, and organized Summit's board of trade. He built his first Summit residence in 1907 at 177 Summit Avenue.

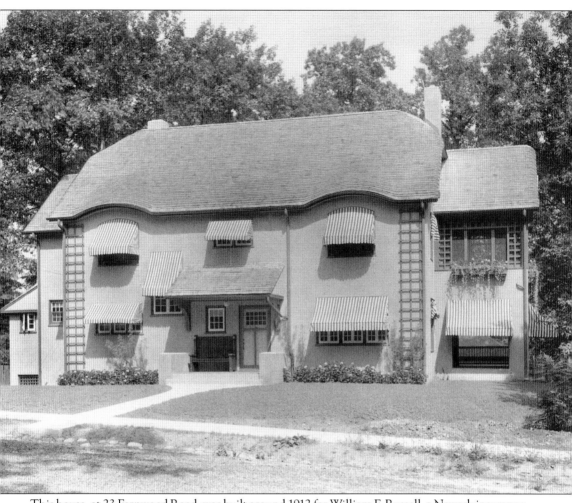

This house, at 23 Fernwood Road, was built around 1912 for William F. Russell, a Newark insurance executive. A photograph of the newly constructed residence was published in the 1912 *Year Book of the Architectural League of New York*. From about 1920 to 1957, the house served as the home of Lt. Col. Edward B. Twombly (1891–1969) and his family. Twombly was a New York attorney and the son of Henry B. and Frances D. Twombly, who lived at 226 Hobart Avenue. He was a veteran of World War I and the recipient of a Silver Star for bravery in action. While residing at this address, Twombly served as a member of common council from 1921 to 1929 and as mayor from 1930 to 1931. In 1957, Twombly and his family left Summit and moved to Short Hills.

PROSPECT HILL
AND
CANOE BROOK ESTATES

PROPERTIES OF
PROSPECT HILL COMPANY
OFFICES ~ WOOLWORTH BUILDING ~ NEW YORK
AND SUMMIT ~ NEW JERSEY

This is the title page of a brochure published in 1913 to promote two new residential developments, Prospect Hill and Canoe Brook Estates. Prospect Hill was located on what was once the Oliver J. Hayes estate. Canoe Brook Estates sat on about 80 acres of land opposite Canoe Brook Country Club. The brochure attempts to appeal directly to city "cliff dwellers" and entice them to move to Summit with glowing promises of a commute "in absolute comfort" and a home in "ideal country surroundings." It goes on to claim, "For the downtown New Yorker the hill country of Northern New Jersey is the ideal place for a home, because of its convenience and healthfulness."

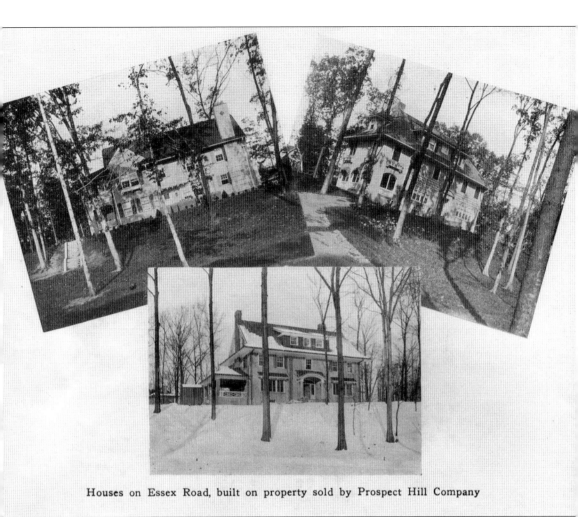

Houses on Essex Road, built on property sold by Prospect Hill Company

This is another page from the 1913 promotional brochure for the Prospect Hill and Canoe Brook Estates developments. Acknowledging that some residents choose to live in Summit for the winter months, while others prefer to spend only the summer season, the brochure attempts to convince its readers that "Summit is, in fact, an ideal all-the-year place of residence." This page features houses on Essex Road that had already been constructed on lots sold by the Prospect Hill Company. It is intended to show prospective buyers in Prospect Hill "the general character" of the homes they are expected to build. Canoe Brook Estates, the brochure notes, is intended to "supplement the more expensive property of Prospect Hill."

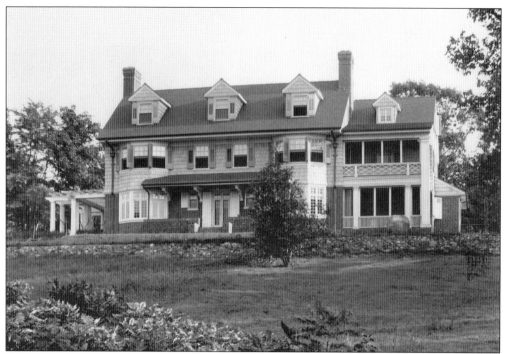

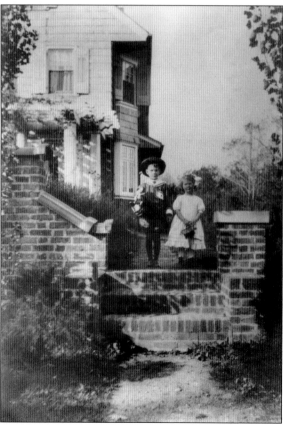

The house above, at 20 Beacon Road, was the home of Summit architect Benjamin V. White (1870–1956) and was designed by him. It was built around 1912 on property previously owned by Dr. William H. Risk. The property may have been inherited by White's wife, Margaret, Dr. Risk's only child. The house appears in the *Summit Herald*'s 1914 supplement. Seen at left on the steps of their home are the Whites' children, Benjamin and Margaret, named after their parents. The family lived here from about 1913 to 1920. During that time, White served on Summit's common council from 1915 to 1917 and with the American Red Cross in France in 1918–1919.

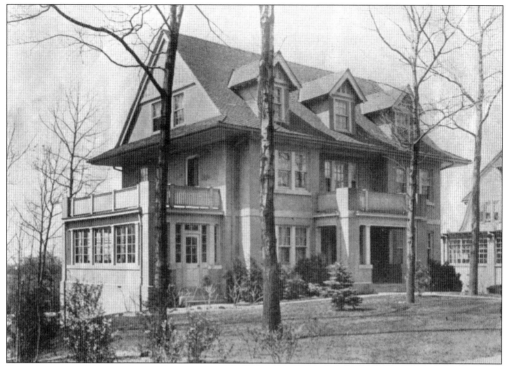

Seen here in 1914 not long after its completion, 73 Oak Ridge Avenue was the home of J.A. Theodore Obrig, a partner with Gall & Lembke, New York opticians. Obrig moved to Summit from Brooklyn and lived here until his death in 1955. An article in the *New York Times* on April 14, 1909, lists this house among the more than 40 residences under construction in Summit.

This view of Sunset Drive appears in the May 1914 illustrated supplement to the *Summit Herald*. George H. Williams (1849–1921), a New York oil merchant and a large property holder in western Summit, started developing the street around 1910. The Williams family residence, Meadowbrook, was located at 768 Springfield Avenue.

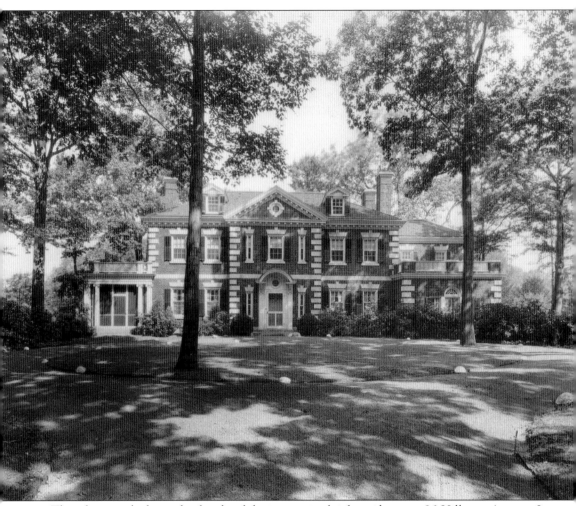

This photograph shows the facade of the impressive brick residence at 96 Hillcrest Avenue. It was built in 1914–1915 for Frederick H. Shipman (1854–1920), the treasurer of the New York Life Insurance Company at the time. Architect Graham King of Manhattan designed the house, and it is said to be an exact reproduction of a Georgian mansion in England called Kenwood. In an October 1914 issue, the *Summit Herald* notifies its readers that a "handsome residence" for Shipman is under construction on Hillcrest Avenue. The paper followed up on August 20, 1915, with the announcement that Shipman and his family were moving into their "beautiful new residence."

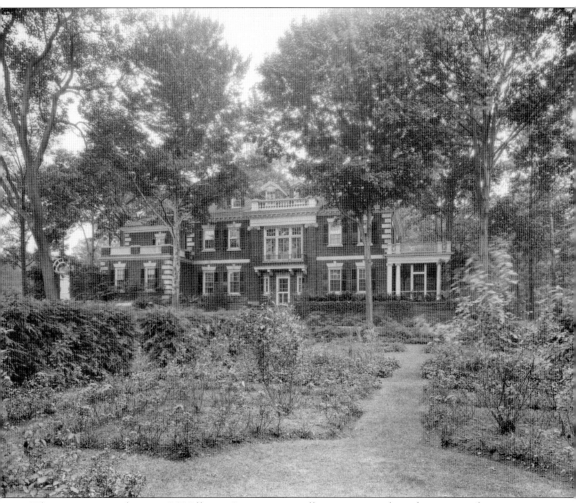

The imposing residence at 96 Hillcrest Avenue originally sat on more than three acres of property. This rear view of the house gives a sense of its expansive yard and beautiful gardens. The home's extensive grounds were the work of New York landscape architects Vitale & Rothery. After Frederick Shipman's death in 1920, the estate was sold to Walter Lee Gwynne, who fittingly renamed it Gywnderwen. Gwynne was a New York stockbroker and the son of Rev. Walker Gwynne, the rector of Calvary Episcopal Church from 1893–1914. In 1928, the property was sold to E.O. Spindler.

This home, at 19 Hobart Road, was constructed in 1916 by Israel Losey White (1872–1935) on a lot he purchased from neighbor Frank Dillingham. The White family moved here in 1916 from their previous home around the corner on Dogwood Drive. Their three children were nicknamed the Israelites. According to one of them, Esther White Cornish, White's pet name for his wife was Gypsy, and that was why they called the house Romany Garth, or Gypsy's Garden. The family lived here until 1926, when they moved to 17 Fernwood Road. Following in the footsteps of his father, Rev. Theodore White, the pastor of Central Presbyterian Church from 1883–1903, Israel originally trained as a minister. That profession did not suit him, however, and by 1910, he was employed as the editor of the *Newark News*. His brother, architect Benjamin V. White, presumably designed this house.

Seven

CITY OF
BEAUTIFUL HOMES
1920s–1940s

From 1920 to 1930, Summit's population grew from 10,715 to 14,556, its largest increase so far. While still drawn by the appeal of an attractive, healthful community with a convenient commute to Newark and New York, those who were moving to Summit were now looking to become full-time residents. With its reputation as an established, premier residential community, Summit continued to attract homebuyers. An illustrated supplement published by the *Summit Herald* in 1925 showcases the residences of the leading citizens of this period and christens Summit "A City of Beautiful Homes."

During this period, Summit's old estates were being subdivided and developed, just as its farms had been in previous times. Promotional materials for the new developments emphasize the same qualities that first attracted summer visitors to the area. Summit, notes a 1926 brochure for Sunset Estates, "is a delightful urban town dotted with dignified, beautiful homes, and estates within easy commuting distance of Newark and New York" and is "known as the Health Spot of New Jersey." Similar language is used in a 1928 pamphlet for Ivanhoe Park, which calls it "the most exclusive residential addition to Summit – New Jersey's beautiful suburban hill city. Only fifty minutes from Broadway on fast trains of the Lackawanna, this new suburban community of infinite charm commands a sweeping view of picturesque country side." A 1929 brochure describes Glen Oaks as a "new and distinctive home colony" located in "a delightful suburban town, which has been chosen by thousands of happy families because of its accessibility and the healthful atmosphere of its altitude."

In 1931, the electrification of the Delaware, Lackawanna & Western Railroad line once again improved the Summit commuter's journey. By 1935, according to a pamphlet produced by several local banks, there were 94 electrified trains running daily between Summit and New York, with a commuting time of 30 minutes.

A 1942 League of Women Voters survey, published in the early days of World War II, pronounces Summit "A Convenient, Healthful and Delightful All Year Home Community." With 100 trains daily and almost 18,000 residents, Summit had completed its transformation from summer destination to fully developed suburb.

This photograph of 22 Essex Road appears in the *Summit Herald*'s 1925 illustrated supplement. The house was built around 1920 for Arthur Henry Rahmann of George Rahmann & Company, his family's leather business in New York. Rahmann's wife, the former Marjorie Bailey, was the daughter of early Summit resident William Bailey. After her husband's death in 1958, Marjorie Rahmann continued living here until 1962.

This photograph also appears in the *Herald*'s 1925 supplement. It shows the magnificent residence that once stood on the corner of Prospect and High Streets. The house was built in about 1919 for Livingston P. Moore, the president of Benjamin Moore & Company, a New York paint business founded by his father and uncle.

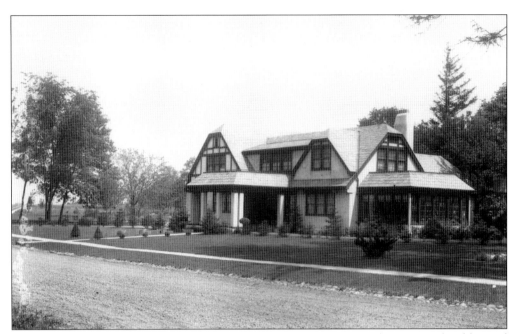

Architect William Oakley Raymond designed 1 Oakley Avenue, on the corner of Oakley and Springfield Avenues, as his personal residence. It was constructed in the early 1920s, about when the street was cut through. This photograph probably dates from then, since no other residences are visible and the street is unpaved.

This house, at 34 Whittredge Road, was built in 1923 for Sarah and Harry T. Rounds. An article on residential real estate activity in the suburbs in the October 8, 1922, *New York Times* mentions the sale of this property, part of the former Dr. William H. Risk estate, to the Rounds among the important transactions in New Jersey.

Summit architect Benjamin V. White designed this home, at 95 Whittredge Road, for Newark banker Edward A. Pruden. It was built in 1922 and is featured in the *Summit Herald*'s 1925 illustrated supplement. Some years later, the house was described by a realtor as "A Home For Gracious Living at Summit, New Jersey; Offered at a Great Sacrifice; With Every Advantage, Comfort and Convenience To Make It An Ideal Home For A Gentleman And His Family Used To The Best." The photograph below shows one of the home's rooms. Its decor echoes the Colonial Revival style of the house's exterior.

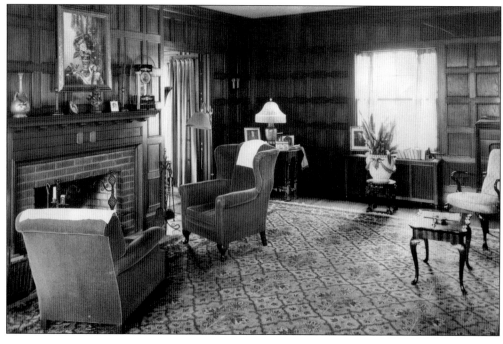

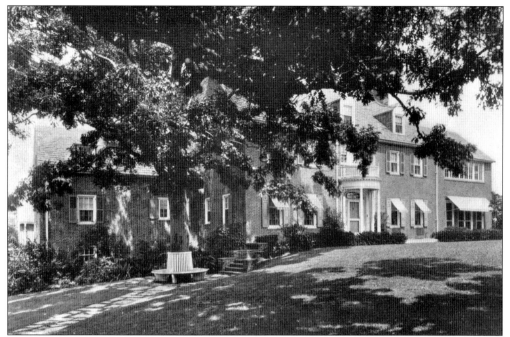

This home, at 20 Prospect Hill Avenue, was built around 1923 for J. Spencer Weed, an executive with the Grand Union supermarket chain. It appears in the *Summit Herald*'s 1925 supplement and was later described by a realtor as "A Delightful Southern Colonial Residence And Landscaped Plot Located In Summit, New Jersey 'The Hill City of Beautiful Homes.'"

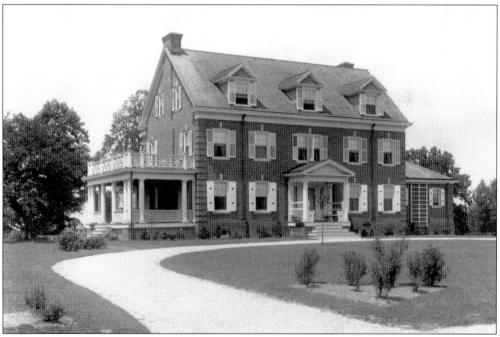

This house, at 316 Summit Avenue, belonged to New York businessman Reginald F. Pearson and his family. Built in about 1923, it also appears in the 1925 illustrated supplement to the *Summit Herald*. It may have been designed by architect Benjamin V. White.

Designed by Forman & Light, this home, at 290 Summit Avenue, is featured in an advertisement for steel casement windows in the September 1927 issue of *Architectural Forum*. It was constructed around 1923 for New York banker George C. Warren (1877–1949), who resided here until his death. Politically active, Warren served numerous terms as president of the New Jersey Fish and Game Commission and founded the New Jersey Conservation Corps.

Referred to in an undated real estate brochure as a "Custom-Built Executive's Home, Summit, N.J.," this house, at 110 Whittredge Road, was built in about 1927 for David C. Waring, an executive with a New York hosiery firm. The Warings lived here until moving to New Hampshire in 1959.

Designed by the New York architectural firm of Cherry & Matz, this impressive Tudor Revival mansion at 3 Essex Road was built around 1929. It was the residence of Willard A. Kiggins, a successful New York businessman, who lived here from 1930 until his retirement in 1956.

This home, at 26 Colt Road, was built in 1929 as part of Woodland Park, a residential development on the site of the former Morgan G. Colt estate. It was designed by R.C. Hunter. The home's original owner, Alice Anderson Stroh, recalled, "We were first attracted to Woodland Park by its beauty."

Part of Ivanhoe Park, 5 Robin Hood Lane has an unusual background. It was built in 1929 for Charles Lott, who had accumulated architectural elements such as hand-hewn beams, leaded-glass windows, and Dutch doors from old houses along the East Coast and instructed his architect to incorporate them into a Normandy-style home. The house won an award in 1930 from *Architectural Forum*.

This is the cover of a brochure published in 1926 to promote the Sunset Estates development, which included Woodland Avenue, Canoe Brook Parkway, Wallace Road, and Iris Road. It describes Summit as "ideally situated in north-eastern New Jersey" and "a delightful urban town dotted with dignified, beautiful homes, and estates within easy commuting distance of Newark and New York."

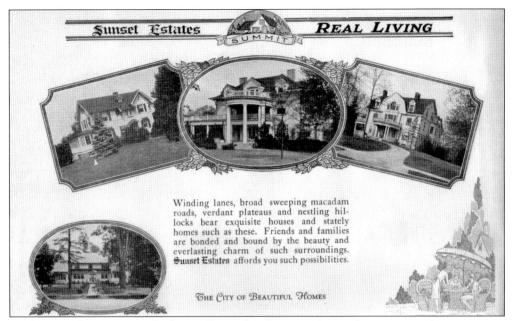

As this page demonstrates, the Sunset Estates brochure was designed to attract readers to move to Summit and experience the gracious life hinted at on its pages. Summit, the brochure states, is "Known as the Health Spot of New Jersey." It also notes, "High prices, zoning laws, and careful city planning have permitted Summit to retain its long established superiority as an ideal community."

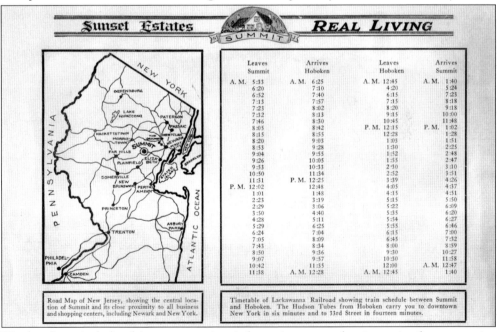

The brochure includes this transportation information as another incentive for prospective homebuyers. It notes that "the transportation facilities of Summit are ideal" and cites more than 60 trains daily to and from Newark and New York, a 20-minute commute to Newark, and a one-hour commute to New York City. A monthly commutation ticket between Summit and New York cost $10.11.

This home, at 280 Oak Ridge Avenue, part of the Druid Hill development, was designed by Lambert B. Pickwick and built in the 1930s. Carroll P. Bassett was the president of the Commonwealth Land Company, which developed this "community of fine homes on the crest of the second mountain in the exclusive suburban city of Summit, N. J.," covering Devon Road, Druid Hill Road, Oak Ridge Avenue, Plymouth Road, and Surrey Road.

Shortly after its completion, this house, at 6 Pembroke Road, was featured in the July 1937 edition of *Architectural Forum* as one of the most outstanding homes of its type. Its owner, David S. Loudon, an executive with George S. Armstrong & Company in New York, designed it.

Eight

Two Summit Architects
Cady and White

Houses constructed in Summit during the period covered by this book were designed by both nationally recognized and lesser-known architects. It is likely that many early houses were based on plans published in popular magazines and then constructed by local builders. Two Summit architects, John Newton Cady and Benjamin Vroom White, designed a large number of homes during this time and deserve special mention. This last chapter provides a brief overview of their work. Other examples are seen in previous chapters.

John Newton Cady (1840–1918) came to Summit in 1883. In 1890, he formed a partnership with fellow architect Nathaniel Brewer Jr. and the firm opened offices in both New York and Summit. Cady and Brewer served as the architects for many of the houses in the Hill Crest development.

In addition to the many private homes he designed, Cady served as the architect for a number of commercial and public buildings. Locally, he is perhaps best known as the architect of the former township hall at 71 Summit Avenue. Cady continued to design buildings and homes right up until his death in 1918. Also active community affairs, Cady was a member of the Union County Board of Freeholders from 1899 to 1918 and served as its president for 16 years.

Another prolific Summit architect was Benjamin Vroom White (1870–1956). He moved to Summit in 1883 when his father, Rev. Theodore F. White, became pastor of Central Presbyterian Church. The Whites were a prominent Summit family and played an active part in the life of the community for many years.

Although he always maintained an office in Manhattan, White practiced almost exclusively in Summit from 1898 until his retirement in 1947. He primarily designed residences but an exception was his design in 1907 of the granite watering trough on Union Place, now located next to the Summit Diner. White was married to Margaret Henderson Risk, Dr. William H. Risk's only daughter. Over the years, they lived in numerous houses in Summit.

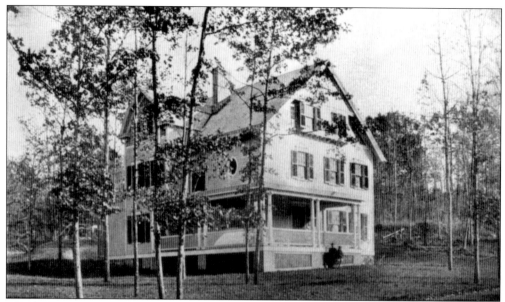

This home, at 25 Hillcrest Avenue, was one of the original houses Cady designed for the Hill Crest development. This photograph appears in an 1891 promotional brochure for Hill Crest. The house's original owner was Michael Jabez Dodsworth (1860–1920), one of the owners of the *Journal of Commerce* in New York. Dodsworth resided here with his family from 1891 until his death. His widow sold the house in 1925.

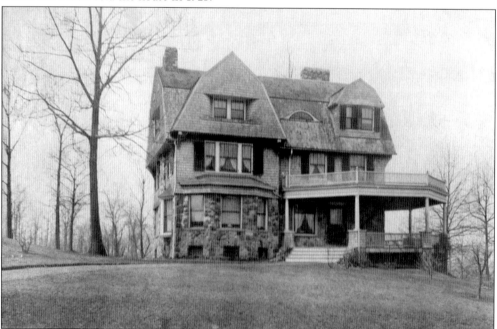

When this house at 212 Summit Avenue was under construction in 1893, the *Summit Record* reported, "The house will be partly in the colonial style of architecture, with first story and chimneys of stone and the upper part shingle. It will have a broad piazza to the east and north, from which can be obtained an expansive view of Boonton and beyond." It was designed by Cady and built for Henry C. Selvage (1842–1901).

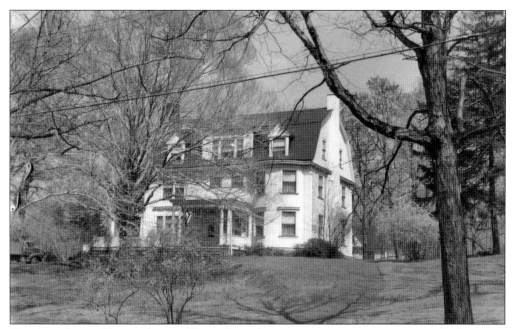

Another of several homes designed by Cady on this street, 193 Summit Avenue was built in 1896 for Frederick C. Clark (1829–1906), the head of Clark, Chapin & Bushnell, an old New York tea-importing firm. Clark and his family moved to Summit from Brooklyn. Cady's own home was at 133 Summit Avenue, which is now the site of an apartment building.

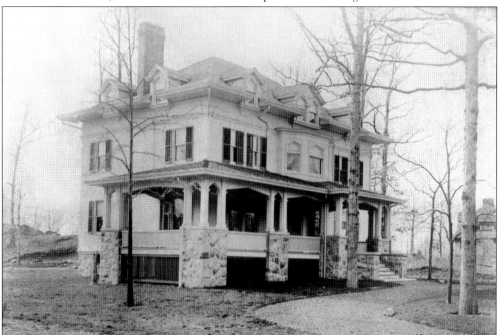

Also the work of Cady, 200 Summit Avenue was completed in 1903 for John M. Long of Spies & Long, a New York firm dealing in men's furnishings. Long moved to Summit in 1898 hoping to improve his health. He lived on Oak Ridge Avenue before building this house. Sadly, he died 10 months after moving in. His wife continued living here until the 1920s.

Cady was also the architect for Beechlawn, at 106 Hobart Avenue, seen on the left in this postcard and built in 1895 for Francis Wayland White (1859–1901) of Whitman Phelps, a New York dry goods firm. White's obituary notes, "The splendid library with which that home was equipped offered something of an index to the character and tastes of its owner."

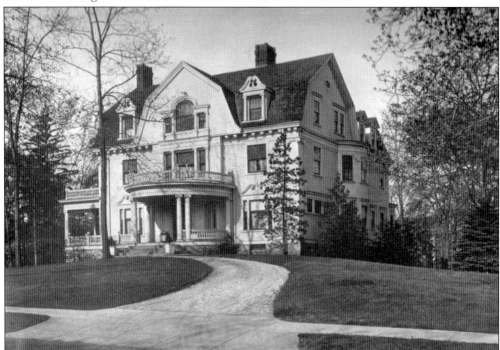

A 1900 *Summit Herald* article describes this recently completed "handsome colonial residence" at 96 Hobart Avenue as "one of the finest and most elaborately finished houses in Summit." Since demolished, it was designed by Cady and built for John Frederick Chamberlin (1843–1905), a New York banker who came to Summit in 1881 and went on to serve as the president of the board of education.

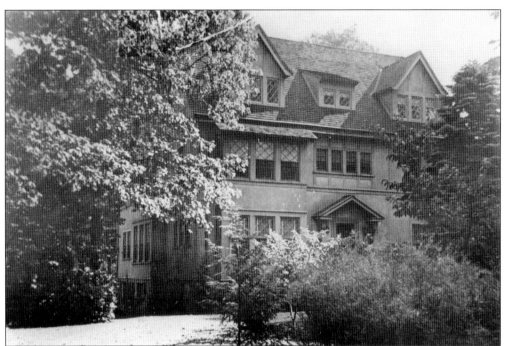

John Frederick Chamberlin built these houses for two of his daughters. He called upon Cady, the architect of his own home across the street, to design both residences. The home above, at 97 Hobart Avenue, was built in 1905 for Chamberlin's daughter Jessie and her husband, William E.F. Moore, around the time of their marriage. At about the same time, Chamberlin built the house next door for another newlywed daughter, May, and her husband, Clarence Berry. Seen at right in front of her aunt and uncle's home at 101 Hobart Avenue is Elizabeth Moore, who lived at 97 Hobart Avenue.

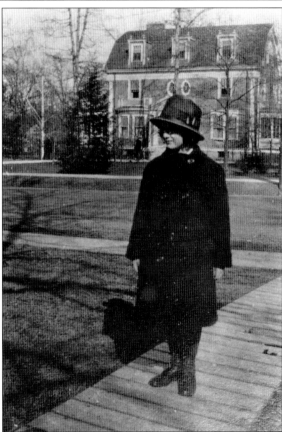

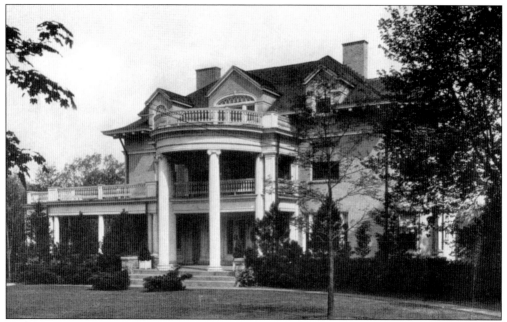

Cady was the architect of this gracious home at 15 Beekman Road, built in 1900 for Joseph H. Shafer (1845–1920), a Newark jewelry manufacturer. Before moving to this house, Shafer resided at 99 New England Avenue.

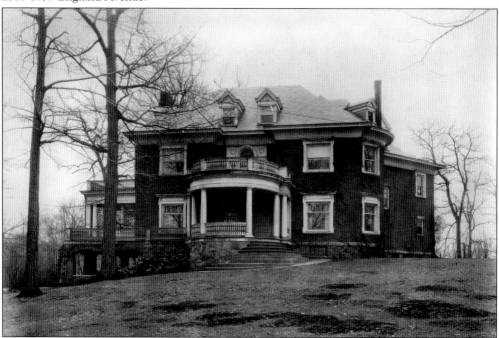

Seen here in 1927, this house at 114 Woodland Avenue (now 1 Woodcroft Road) was designed by Cady and built around 1900 on part of the Theodore Berdell estate. It was the home of Charles Emery Finney (1860–1925), an executive with the America Smelting & Refinery Company and no doubt an acquaintance of Berdell's. Finney served on common council from 1904 to 1905 and resided here until moving to California in about 1913.

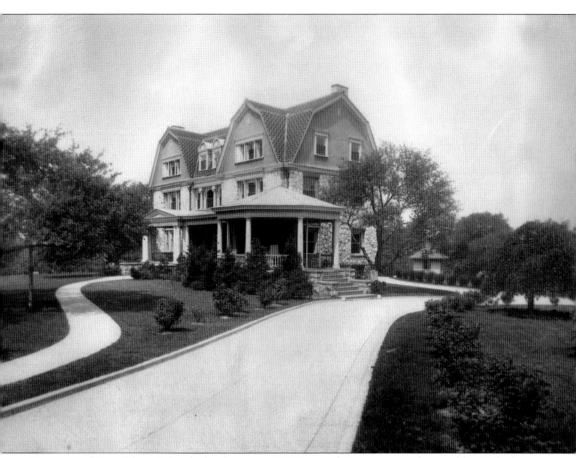

Now part of Kent Place School, this house, at 75 Norwood Avenue, was designed by Cady for Charles P. Berdell. When the house was finished in 1902, a local paper commented, "Summit, the 'Hill City,' is justly noted for its many handsome residences of New York business men, and among them there is none more handsome than that of Charles P. Berdell but recently completed, located on the corner of Norwood and Morris avenues. It sets well back from the street, with a fine hard driveway leading in and surrounded by a spacious and well graded lawn with a fir edge extending the whole length. The white building, with its red tile roof, catches the eye on the right as one follows the winding course of Norwood avenue." It was originally next to Berdell's brother Theodore Berdell's estate, Nuthurst. While this house is still standing, Nuthurst has been demolished.

The earnest young man at left is Benjamin Vroom White. He designed the home below, at 208 Summit Avenue, for prominent New Jersey Republican John Reynard Todd (1868–1945). Todd owned homes in several other locations, but used this as his primary residence. In 1920, he founded the Todd, Robertson, Todd Engineering Corporation that was involved with the construction and management of several prestigious New York buildings, including Rockefeller Center. Completed in 1906 and owned by the Todds until the 1950s, this residence is featured in the 1906 *Yearbook of the Architectural League of New York* and the *Summit Herald*'s 1914 supplement. Since 1957, it has been home to the congregation of Temple Sinai.

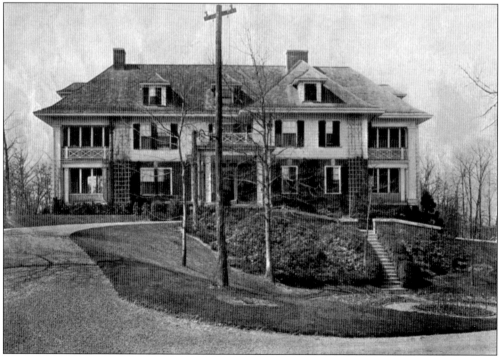

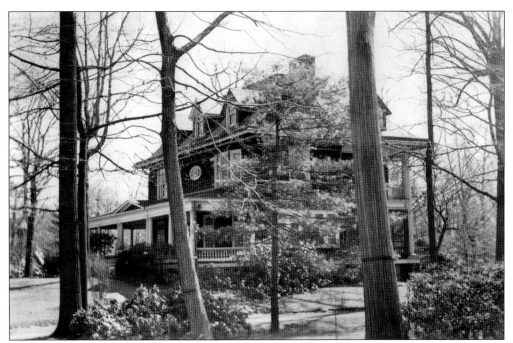

This residence, at 47 Whittredge Road, was designed by White and built in 1902 for Dr. Charles S. Hardy (1866–1945), a dentist credited with establishing dental clinics in the public schools of Union County in the early 1900s. Born in Canada, Hardy lived and practiced in Summit for 50 years.

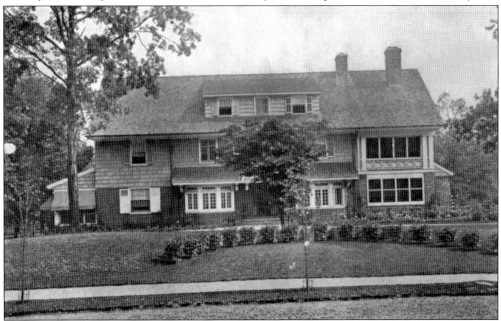

Seen here in 1914, this White-designed home at 19 Ridge Road is featured in the 1911 *Year Book of the Architectural League of New York*. Francis H. Bergen (1863–1932), Summit's mayor from 1914 to 1915, resided here from about 1910 until 1932. Bergen was a New York attorney and the private secretary of real estate investor William Bayard Cutting. When Cutting died in 1912, he left Bergen his Summit real estate holdings.

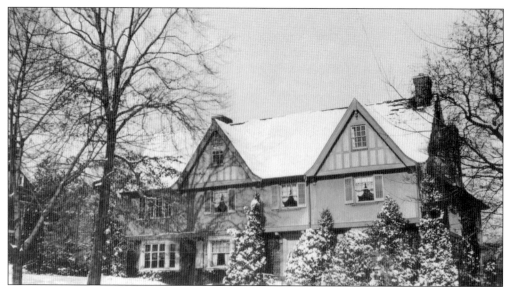

One of the several residences on this street designed by White, this home at 56 Whittredge Road was built in 1916 for Henry Olin Wilson. An article in the April 21, 1916, *Summit Herald* titled "Building in Progress: Numerous Houses Under Way in Different Parts of the City" mentions that work on Wilson's house is underway.

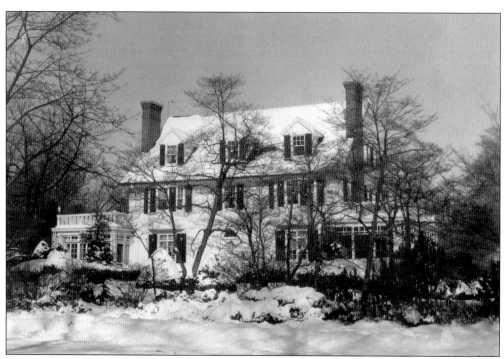

White also served as the architect for 60 Whittredge Road. It was built in about 1917 for Frank Hawkins Appleton (1882–1948), a New York businessman in marine insurance. Appleton purchased this lot in 1915 from the Dr. William H. Risk estate and lived here with his family until moving to California in 1934.

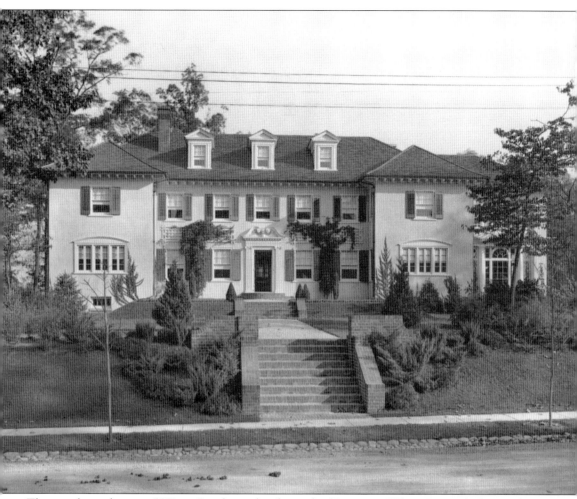

This stately residence at 55 Essex Road was also the work of Benjamin White. It was the home of Elizabeth B. Andrews (1874–1953) and was completed at about the time she moved from Newark to Summit in 1911. Evidently independently wealthy, Andrews was actively engaged in the community. She helped found both the Neighborhood House and the American Women's Club of North Summit and was also involved with Central Presbyterian Church, the Fortnightly Club, and the Red Cross. Her friend Ida A. Rosenquest lived here with her for many years. Rosenquest was also active in Summit life and contributed her time to the YWCA, Calvary Church, the Red Cross, and the Fortnightly Club. Andrews lived in the house until she passed away in 1953.

BIBLIOGRAPHY

Bianculli, Anthony J. *Iron Rails in the Garden State*. Bloomington and Indianapolis: Indiana University Press, 2008.

Clayton, W. Woodford, ed. *History of Union and Middlesex Counties*. Philadelphia: Everts and Peck, 1882.

Holly, Henry Hudson. *Country Seats*. New York: D. Appleton & Co., 1863.

Honeyman, A. Van Doren. *History of Union County, New Jersey 1664–1923*. New York: Lewis Historical Publishing Company, 1923.

Illustrated Supplement of the Summit Herald. Summit, NJ: The Summit Herald Publishing Company, Friday, May 22, 1914.

Olcott, Edward S. *20th Century Summit, 1899–1999*. Summit, NJ: Howell and Williams, 1998.

Perrottet, Louis J. *Summit Heritage: Three Historical Essays*. Summit, NJ: Summit Historical Society, 1971.

Picturesque Summit, Madison, Chatham and Milburn. New York: Mercantile Illustrating Company, 1894.

Raftis, Edmund. *Summit, New Jersey: From Poverty Hill to The Hill City*. Seattle: Great Swamp Press, 1996.

Ricord, Frederick W. *History of Union County, New Jersey*. Newark, NJ: East Jersey History Company, 1897.

Stilgoe, John R. *Borderland: Origins Of the American Suburb, 1820–1939*. New Haven, CT: Yale University Press, 1988.

Summit New Jersey – The Hill City – An Ideal Suburban Home Town. Newark, NJ: Civic Publicity Company, 1909.

Summit, Short Hills and Vicinity in Pictures. Summit, NJ: Summit Herald Publishing Company, 1925.

The Summit And Life and Times of The Commuter. Pamphlet prepared especially for Centennial Committee of Summit by the Erie Lackawanna Railway, April 1969.

Witteman, A. *Souvenir of Summit N.J.* New York: Albertype Company, 1894.

About the Summit Historical Society

Founded in 1929, the Summit Historical Society actively pursues the preservation and dissemination of information about Summit's past. Headquartered in the 1741 Carter House, Summit's oldest building, the society maintains a vast archive of research materials, including photographs, genealogies, files on Summit houses, property deeds, maps, newspapers, postcards, yearbooks, city tax atlases, and city directories dating back to 1890. The collection is available to the public, and new items relating to Summit's past are continually being added. The Carter House also serves as a local history museum. Volunteers are available for assistance with research and guided tours. The Summit Historical Society is located at 90 Butler Parkway, Summit, New Jersey, 07901.

Discover Thousands of Local History Books Featuring Millions of Vintage Images

Arcadia Publishing, the leading local history publisher in the United States, is committed to making history accessible and meaningful through publishing books that celebrate and preserve the heritage of America's people and places.

Find more books like this at
www.arcadiapublishing.com

Search for your hometown history, your old stomping grounds, and even your favorite sports team.

Consistent with our mission to preserve history on a local level, this book was printed in South Carolina on American-made paper and manufactured entirely in the United States. Products carrying the accredited Forest Stewardship Council (FSC) label are printed on 100 percent FSC-certified paper.

MADE IN THE USA